S0-AJG-041

collecting
CULINARIA

cookbooks and domestic manuals mainly
from the Linda Miron Distad Collection

UNIVERSITY OF ALBERTA
LIBRARIES

Bruce Peel Special Collections Library
University of Alberta

24 October 2013 – 7 February 2014

collecting
CULINARIA

cookbooks and domestic manuals mainly
from the Linda Miron Distad Collection

Caroline Lieffers & Merrill Distad

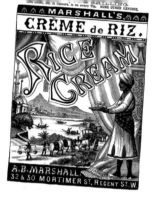

Copyright © University of Alberta Libraries 2013
All rights reserved. The use of any part of this publication — reproduced, transmitted in any form or by any means, electronic, mechanical, recording or otherwise, or stored in a retrieval system — without the prior consent of the publisher is an infringement of the copyright law.

Bruce Peel Special Collections Library
B7 Rutherford South
Edmonton, Alberta, Canada
T6G 2J4

Library and Archives Canada Cataloguing in Publication

Collecting culinaria : cookbooks and domestic manuals mainly from the Linda Miron Distad Collection / by Caroline Lieffers & Merrill Distad.

This exhibition catalogue presents selected works from the Linda Miron Distad Collection, as well as some supplementary titles, held at the University of Alberta Libraries, and will be on display in the Bruce Peel Special Collections Library from October 24, 2013 to February 7, 2014.

Books in this exhibition are housed in the Bruce Peel Special Collections Library and the others are housed within the University of Alberta Libraries.
Includes bibliographical references.

ISBN 978-1-55195-324-3 (pbk.)

 1. Distad, Linda--Books and reading--Exhibitions. 2. Cooking--Bibliography--Exhibitions. 3. Cookbooks--Private collections--Edmonton--Alberta--Exhibitions. 4. Cooking--History--Exhibitions. 5. Home economics--Bibliography--Exhibitions. 6.Bruce Peel Special Collections Library--Exhibitions. 7. University of Alberta. Library--Exhibitions. I. Distad, N. Merrill (Norman Merrill), 1946-, writer of added commentary II. Distad, Linda III. Lieffers, Caroline, 1986-, writer of added commentary IV. Bruce Peel Special Collections Library, host institution V. University of Alberta. Library, issuing body

TX6.A43C64 2013 641.509 C2013-905729-3

Design and layout: Kevin Zak
Editorial: Leslie Vermeer
Digital reproduction: Jeff Papineau
Exhibition installation: Carol Irwin

First edition, first printing, 2013
Printed in Canada by Friesens Corporation

Foreword

Making Others Better Than They Are

So few of us are natural servants to others. Few have come to the fullness of their character through helping others perfect what they care about and what they need to do. Linda Distad was among those rare few, and her perfection was worked out preparing the table of hospitality and in the vineyard of the word. Attentive to the seasons, Linda carefully bought the best vegetables, locally picked mushrooms, sausages, or cuts of bison from the many farmers, gardeners, and butchers she got to know at the markets of Edmonton over her well-ordered life. The care and enjoyment she took every week in these early-morning hunting and gathering forays were matched by her skill and pleasure in preparing what was on offer and presiding over a table at which the dietary particulars and culinary delights of each guest were met with the perfection of the gifts of the earth and others' labour. All done without fanfare. All done as invitation: to be for a time, in the enjoyment of others.

Her skills at harvesting and calling forth just the right combinations of flavours, in seating guests in proximities that brought forth the best in the company, this attentiveness and knowledge we so often appreciated and remember with gratitude

were paralleled, I think, in the person we first met as editor and researcher. Not as odd a combination as one might think. We who work in the "vineyard of the word" brought sometimes rough and unready fruit to her in the confidence that she would sort through the basketful (or overflowing bushels!) and make them not only digestible but palatable. She took manuscripts with infelicities and missteps, paragraphs that overreached or didn't say quite enough or didn't mean what they said, misidentified footnotes and incomplete research, and with the speed and skill of a sous-chef in the best French restaurant she would trim, peel, combine, separate, enhance, reduce, clarify, liaise, always staying true to the original concept. The contents of the basket or bushels would come back with a clarity of thought and elegance of form that you knew were yours. Linda and David worked together for over a quarter century. Others had worked with her longer. "A good editor is a joy forever," words we learned over this halcyon time. Linda made many of us better than we were. She would deny these words. But we all knew.

— David J. Goa and Anna E. Altmann

Introduction

At least since the days of Apicius, a Roman gourmand of the first century CE, whose cookbook, known as *De Re Coquinaria* (*The Art of Cooking*), survives in two manuscripts of about the fourth century CE, people have exchanged and collected recipes. Scrapbook compilations of recipes are still being handed down in families, typically from mothers to daughters and granddaughters. More formal, published cookery books began to proliferate in the nineteenth century with the downward social spreading of literacy, and in the early twenty-first century, as the reading public evinces an ever-growing interest in food and its consumption, cookbooks have become one of the most numerous genres in the world of publishing. Paralleling this development is an increasing interest by historians in the social and economic history of food, cooking, and dining habits, subjects once mainly the province of anthropologists and sociologists. Appropriately, much of this impetus has come from scholars in France, the seventeenth-century birthplace of modern Western cuisine, of the restaurant, and of the first chefs to achieve international success and recognition. Future research will depend in some measure on access to *culinaria* preserved in institutional

collections, although *culinaria* is not a subject that has traditionally been acquired and collected by most academic libraries. This exhibition features highlights from one such collection, assembled by the late Linda Distad, as well as some supplementary titles, held by the University of Alberta Libraries.

Linda Miron Distad (née Connors, 1944–2012) said that she "began cooking as soon as [she] was tall enough to reach the stove." Raised in a "meat-and-potatoes" culinary environment, she later cultivated a far more cosmopolitan taste in food that ranged from French *haute cuisine* to traditional ethnic fare. This diversity is reflected by the strong emphasis on national and regional cookbooks, of which she aimed to collect at least one example from every country and region in the world, although France and Italy are much more abundantly represented in the Collection.

Persuaded at an early age by her mother that "Home Economist is a fine career for a woman," Linda pursued that goal through two years of undergraduate study. Adding several languages to her curriculum, she aimed to work in the international field, to combine foreign travel with her professional vocation. However, an unsympathetic dean, scornful of such goals, led her

to abandon home economics and instead complete her honours degree with a double major in German and Arabic. This change of plan led, happily, to meeting and becoming engaged to her future husband. She had been accepted for graduate work in Islamic Studies by the University of Chicago and planned to matriculate there after spending the summer in Cairo at an Egyptian institute for Islamic studies. That June, however, the Six-Day War erupted between Israel and its Arab neighbours, and the summer institute in Cairo was cancelled. So instead of making her planned *Hijra* to Cairo and Chicago, she

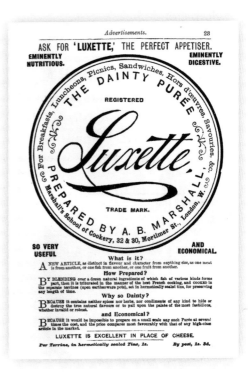

Advertisements. 23

ASK FOR 'LUXETTE,' THE PERFECT APPETISER.

EMINENTLY NUTRITIOUS. EMINENTLY DIGESTIVE.

THE DAINTY PURÉE

For Breakfasts, Luncheons, Picnics, Sandwiches, Hors d'œuvres, Savouries, &c.

REGISTERED

Luxette

PREPARED BY A. B. MARSHALL, London, W.

Marshall's School of Cookery, 32 & 30, Mortimer St.,

TRADE MARK.

SO VERY USEFUL AND ECONOMICAL.

What is it?

A NEW ARTICLE, as distinct in flavour and character from anything else, as one meat is from another, or one fish from another, or one fruit from another.

How Prepared?

BY BLENDING over a dozen natural ingredients of which fish of various kinds forms part, then it is triturated in the manner of the best French cooking, and COOKED in the separate terrines (open earthenware pots), set in hermetically sealed tins, for preserving any length of time.

Why so Dainty?

BECAUSE it contains neither spices nor herbs, nor condiments of any kind to hide or destroy the true natural flavours or to pall upon the palate of the most fastidious, whether invalid or robust.

and Economical?

BECAUSE it would be impossible to prepare on a small scale any such Purée at several times the cost, and the price compares most favourably with that of any high-class article in the market.

LUXETTE IS EXCELLENT IN PLACE OF CHEESE.

For Terrines, in hermetically sealed Tins, 1s. *By post, 1s. 3d.*

stayed home, married, and went to library school, thus allowing her husband, Merrill, to boast of being "one of the very few people to have profited from the Six-Day War who wasn't selling guns to the Arabs or the Israelis."

As they were the only married couple among their circle of friends and fellow graduate students, the Distads' large apartment, located in an old house near the campus, became a social gathering place where they entertained and fed friends and fellow students once, or sometimes twice, a week. That accounted for a weekly liquor bill as large as their grocery bill. It was in those halcyon student days that Linda began building her culinary repertoire and her reputation

as an excellent cook and gracious hostess. She approached the planning of a formal dinner party in the spirit of the German army's general staff preparing an invasion plan. Once she had decided upon a theme, hours would be consumed in consulting appropriate cookbooks for inspiration. But only inspiration, because she rarely followed a recipe exactly as it was written, more often preferring to draw inspiration from several variants of the same dish and then developing her own. Once a menu had been crafted, she would spend the better part of a day shopping for ingredients. She would then devote a minimum of two days to advance preparation and cooking. After relocating to Edmonton from the Toronto area, Linda revelled in the abundance of the Downtown and Strathcona Farmers' Markets, where she was a familiar figure. Hating to repeat herself in her menus, she was always looking for new dishes to try. But unlike nervous cooks, who compulsively test new recipes on family members before risking them on their guests, Linda almost never did. She preferred to cook — as she put it — "without a safety net." The price of an invitation to what some have labelled her "legendary" dinner parties was only a prospective guest's ability and willingness to provide stimulating conversation.Linda loved her work as a bookmobile librarian, but her real passion was learning about things. A self-described scholarly "hunter-gatherer," she made a second career for herself doing contract and for-hire research and editorial work, services that proved popular over the years with clients. These skills, combined with her love of gadgets and new technology — whether for the kitchen or for her office — led her to throw herself into mastering new electronic appliances, hardware, and software. In addition to sharing a love of good food and wine, Linda and husband Merrill shared a common bibliophilia, and over

the years their personal library expanded considerably. A growing interest in food history, combined with a lengthy sojourn in England in 1971–72, led to the acquisition of numerous antiquarian titles. Linda's acquisitions increasingly focused on cookbooks and the history of food, with a determination that once led her, while awaiting the proprietor's return from lunch, to block the doorway of an antiquarian bookshop in Cambridge to prevent anyone else from scooping up a copy of *Mrs Marshall's Larger Cookery Book* (1891) that was conspicuously displayed in the shop's front window. Her husband willingly accepted her explanation that "the cookbooks really must be breeding in the dark," because it defused much of her annoyance at his own expenditures on books. To make room for new acquisitions, Linda weeded her collection of cookbooks with

an enviable degree of discipline and each year made multiple donations to the University of Alberta Libraries. She was, however, so modest and self-effacing that she was "not amused" by the establishment of a subject collection bearing her name, complete with donor bookplates and donor provenance notes in the catalogue records.

Ex Libris
Universitatis
Albertensis

Linda Miron Distad
Culinaria Collection

7 February 2009
"Robbie Burns Night" + Scottish Enlightenment

leek-potato bisque with salmon tartare
oat cakes Kathryn Merrett

Scottish multivegetable salad
salad Dale and Sandra

rumbledethumps Lawrence *Scottish Kitchen* 160
haggis patties
skirlie
onion confit *Bon Appétit* 147
parsnip cakes *Bon Appétit* 139
Tweed kettle Lawrence *Scottish Cooking* 47
anchovy-caper mayonnaise *~How to cook Everything*
black-pepper sabayon *Bon Appétit* 182
spiced beef Trotter 80
cucumber & ginger salad Lawrence *Scottish Cooking* 82

gingerbread with marmalade *Bon Appétit* 95
Drambuie cream Warren 146
 raspberry coulis (dry pack frozen)
no-flour nutty chocolate cake Lawrence *Scottish Kitchen* 29

Alan and Rendene Rutkowski
Dale Gibson and Sandra Anderson
Kathryn and Rob Merrett

The **Linda Miron Distad Culinaria Collection** currently has more than three thousand titles listed in the University of Alberta Libraries' on-line catalogue, with a goodly number still in the processing pipeline. Once the remaining titles dealing with food history and biography, botany, and horticulture have been formally donated to the Library, that number will rise substantially. The antiquarian titles are housed in the Bruce Peel Special Collections Library. Although these represent only a small fraction of the books in the Linda Distad Collection — the bulk of which are housed in the Book and Record Depository (BARD) — memorial donations from friends and admirers have enabled further acquisitions, including several unique manuscript cookbooks, whose research potential awaits exploration by social historians who share Linda Distad's strong interest in *culinaria*.

For this is Wisdom: to love, to live,
To take what fate, or the gods, may give.
To ask no question, to make no prayer,
To kiss the lips, and caress the hair.
Speed passion's ebb, as you greet its flow,
To have, to hold, and, in time, let go.

— Laurence Hope
[pseudonym of Adela Florence Nicholson, 1865–1904]

Linda's file of her dinner-party menus — with guest lists and recipe sources — preserves a record of forty-five years of entertaining.

DICTIONNAIRE
PORTATIF
DE CUISINE,
D'OFFICE,
ET DE DISTILLATION;

CONTENANT la maniere de préparer toutes fortes de viandes, de volailles, de gibier, de poiſſons, de légumes, de fruits, &c.

La façon de faire toutes fortes de gelées, de pâtes, de paſtilles, de gâteaux, de tourtes, de pâtés, vermichel, macaronis, &c.

Et de compoſer toutes fortes de liqueurs, de ratafiats, de ſyrops, de glaces, d'eſſences, &c.

OUVRAGE également utile aux Chefs d'Office & de Cuiſine les plus habiles, & aux Cuiſinieres qui ne font employées que pour des Tables bourgeoiſes.

ON Y A JOINT des Obſervations médecinales qui font connoître la propriété de chaque Aliment, relativement à la Santé, & qui indiquent les mets les plus convenables à chaque Tempérament.

NOUVELLE ÉDITION,

Revue, très-corrigée, & enrichie d'un grand nombre d'Articles refaits en entier.

A PARIS,

Chez LOTTIN le jeune, Libraire, rue S. Jacques, vis-à-vis la rue de la Parcheminerie.

M. DCC. LXXII.
AVEC APPROBATION, ET PRIVILEGE DU ROI.

Dictionnaire portatif de cuisine, d'office, et de distillation. New edition. Paris: Lottin le jeune, 1772.

18th century

The eighteenth century is notable for the increasingly wide reach of printed cookbooks, available in greater numbers and aimed at a wider variety of readers, including the middling sorts and even servants. While the century began with two dominant cookbook genres — court cookery by male authors and domestic cookbooks written by women — it soon

became clear that the latter, usually in a more modest style based on manuscript cookbooks, were more suited to the requirements of readers.[1] E. (probably Eliza) Smith's *Compleat Housewife*, for example, which first appeared in 1727 and continues to be reprinted today, adapted from or outright replaced more courtly recipes, "for many of them to us are impracticable, others whimsical, others unpalatable, unless to depraved Palates; some unwholesome" ([vi]). In addition to accessible recipes for cooking a variety of foods nearly unknown today, Smith included medicinal receipts, which a charitable gentlewoman might use to help her less fortunate country neighbours. Such richly diverse contents followed the tradition of early modern manuscript receipt books, in which women documented their invaluable and intertwined roles of nourishing and healing alike.

Still, books by male authors remained popular. *The London Complete Art of Cookery*, for example, was a rip-off of John Farley's highly successful *London Art of Cookery* — a ghostwritten book that played on the supposed author's reputation as a cook at the popular London Tavern, even if its recipes were themselves entirely pillaged from

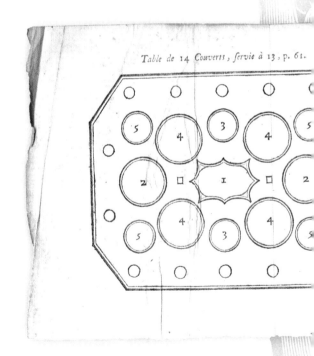

Table de 14 Couverts, servie à 13, p. 61.

NOUVEAU TRAITÉ
DE
LA CUISINE,
AVEC
DE NOUVEAUX DESSEINS
DE TABLES
ET
VINGT-QUATRE MENUS;

Où l'on apprend ce que l'on doit fervir fuivant chaque Saifon, en gras, en maigre, & en Pâtifferie; & très-utiles à toutes les perfonnes s'en mêlent, tant pour ordonner, que exécuter toutes fortes de nouveaux ûts, & des plus à la mode.

TOME PREMIER.

PARIS, AU PALAIS;

PAULUS-DU-MESNIL, Imprimeur - Libraire, rand'Salle, au Pilier des Confultations, au Lion d'or.

M. DCC. XXXIX.

APPROBATION ET PRIVILEGE DU ROI

DE LA CUISINE. 61

MENUS
e Table de quatorze couverts fervie à treize, à fouper, au mois de May.

PREMIER SERVICE.
1. Pour le milieu une machine.
Pour les deux bouts de la machine deux pots à Ouille.
Un d'une Ouille au naturel; Un d'un ris au blanc.
Pour les deux flancs deux hors-d'œuvres.
de Pigeons au foleil.
d'un pain en côtes de melon.
Quatre moyennes Entrées aux quatre coins de la machine.
e d'un Pâté de Macreaux.

[Menon]. *Nouveau traité de la cuisine*. Tome Premier. Paris: Paulus-du-Mesnil, 1739.

*The London Complete Art
of Cookery.* London:
William Lane, 1797.

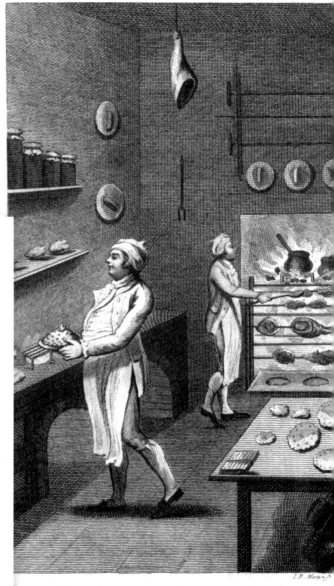

THE

LONDON

COMPLETE

ART of COOKERY.

CONTAINING THE

MOST APPROVED RECEIPTS

EVER EXHIBITED TO THE PUBLIC;

SELECTED WITH CARE FROM THE

NEWEST EDITIONS OF THE BEST AUTHORS,

FRENCH AND ENGLISH.

ALSO

THE COMPLETE BREWER;

EXPLAINING THE ART OF BREWING

PORTER, ALE, TWOPENNY, AND TABLE-BEER;

INCLUDING THE

PROPER MANAGEMENT OF THE VAULT OR CELLAR.

PRINTED FOR WILLIAM LANE,

AT THE

Minerva-Press,

LEADENHALL-STREET.

M DCC XCVII.

London Art of Cookery

J. R. Marten ſc

other texts.[2] But even male cookbook writers increasingly appealed to more diverse readers: Menon, proponent of the lighter and more delicate and refined *nouvelle cuisine*, first published *La Cuisinière bourgeoise* in 1746, a text meant for broad use in the homes of the middling sorts rather than more opulent environments. The book became a classic of French cookery, and in fact was probably the first cookbook published in Canada, in 1825.[3] *Dictionnaire portatif de cuisine* similarly asserted its suitability as a reference for both wealthy and middling tables. But despite their varied authors and audiences, these early printed cookbooks share a pedagogic aim: culinary knowledge and practices both common and esoteric were now captured and offered to many new readers through the growing marketplace of books.

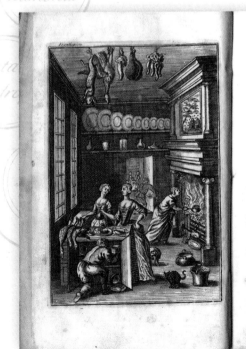
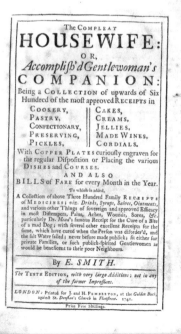

Smith, E. *The Compleat Housewife: or, Accomplish'd Gentlewoman's Companion.* 10th edition. London: J. and H. Pemberton, 1741.

The Cook Not Mad;
or, Rational Cookery.
Kingston: James
Macfarlane, 1831.
Facsimile reprint.
Toronto: R.A.
Abrahamson, 1972.

Black, Mrs.
[Margaret].
*Household Cookery
and Laundry Work*.
New and enlarged
edition. London:
William Collins,
Sons, & Co.
[c. 1900?].

THE

COOK NOT MAD;

OR

RATIONAL COOKERY:

BEING

A COLLECTION OF ORIGINAL AND SELECTED

RECEIPTS,

Embracing not only the art of curing various
kinds of Meats and Vegetables for future
use, but of Cooking, in its general
acceptation, to the taste, habits,
and degrees of luxury, pre-
valent with the

CANADIAN PUBLIC,

TO WHICH ARE ADDED,

Directions for preparing comforts for the Sick
...........sundry miscellaneous
...........importance to house-
...........early all tested by
...........ence.

...N, U. C.
...es *Macfarlane.*

HOUSEHOLD COOKERY

AND

LAUNDRY WORK.

BY

MRS. BLACK, F.E.I.S.

ONE HUNDRED AND FORTY-NINTH THOUSAND.
NEW AND ENLARGED EDITION.

COLLINS
CLEAR
TYPE
PRESS

LONDON AND GLASGOW:
WILLIAM COLLINS, SONS, & CO. LTD.
COLLINS' CLEAR-TYPE PRESS.
[All Rights Reserved.]

19th century

The Cook Not Mad, first produced in New York in 1830, slipped across the border and was reprinted in Kingston the following year, becoming the first English cookbook published in what is now Canada. Although the title was changed to reflect "Canadian" rather than "American" cookery, the text was not revised, so references to the

"*American Publick*" and "[g]ood *republican dishes*," for instance, remain (iii). The book is also notable for its devotion to "Rational Cookery": cookbooks from this period are often marked for their emphasis on systematic, scientific modes of cookery and household management. This trend originated in the eighteenth century and found wide fruition in the nineteenth, especially as newly middle-class women, often far from their parents' homes, looked for ways to preserve economy while affirming their status. Many cookbooks explicitly espoused such rational values: the epigraph in Mrs. Mary Randolph's *The Virginia Housewife: or, Methodical Cook*, for example, reads "Method is the soul of management," and the preface boasts of

Marshall, Agnes B. *Mrs. A.B. Marshall's Larger Cookery Book of Extra Recipes*. London: Marshall's School of Cookery, 1891.

Smiles, Samuel. *Happy Homes and the Hearts That Make Them or Thrifty People and Why They Thrive*. Revised edition. Chicago: U.S. Publishing House, 1886.

Yours sincerely
Agnes B Marshall

the author's compulsion to "study the subject, and by actual experiment to reduce every thing in the culinary line, to proper weights and measures" (ix). Methodical housekeeping was not simply practical; it was also strongly associated with success and good character. Samuel Smiles's *Happy Homes*, for example, encouraged diligence, thrift, and order for the achievement of happiness and moral satisfaction. New modes of recipe layout also reflected and encouraged more scientific modes of thought: Eliza Acton's *Modern Cookery*, first published in 1845, separated ingredients and their quantities from the cooking instructions, a format that influenced later writers like Mrs. Beeton and has become standard to the present day.

Many books from the period also gave attention to new technologies like ranges and freezing machines, while manufactured foods began to make their mark toward the end of the century.

James, Alice L. *Catering for Two: Comfort and Economy for Small Households.* New York: G.P. Putnam's Sons, 1898.

In addition to running a cooking school in London, Agnes Marshall, for example, sold patented kitchen equipment and foodstuffs, which her recipes often prescribe. Marshall's tastes, it should be noted, also stray from the heavier, more complex items that characterize earlier cookbooks (such as the intensive "To collar Pig's Head" in Maria Rundell's extremely popular *New System of Domestic Cookery*, for example), toward more decadent dishes increasingly influenced by the late nineteenth century's growing restaurant culture.[4] But these books remain, for the most part, highly prescriptive — despite the reality that no cookbook, regardless of its idealized exhortations of domestic order, could control the true chaos of life. Scholars and collectors should perhaps be skeptical of immaculate texts: Mabel Lang's well-loved copy of *The Home Cook Book*, first published in 1877 and identified as Canada's first community cookbook, is a mess of

[Rundell, Maria]. *A New System of Domestic Cookery.* London: John Murray, 1823.

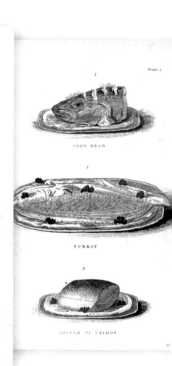

A

NEW SYSTEM

OF

DOMESTIC COOKERY;

FORMED UPON

PRINCIPLES OF ECONOMY:

AND ADAPTED TO THE

USE OF PRIVATE FAMILIES.

BY A LADY.

MRS ELIZA RUNDELL

A NEW EDITION, CORRECTED.

LONDON:

JOHN MURRAY, ALBEMARLE-STREET:

SOLD ALSO BY

LONGMAN, BALDWIN, RICHARDSON, HARDING AND CO., WHITTAKER, UNDERWOOD, LONDON; WILSON, YORK; MOZLEY, DERBY; MANNERS AND MILLER, AND OLIVER AND BOYD, EDINBURGH; CUMMING, MILLIKEN, AND KEENE, DUBLIN.

And by every Bookseller and Newsman in Town and Country.

1823.

Price Seven Shillings and Sixpence in Boards.

FRONTISPIECE.

DOMESTIC COOKERY

Published as the Act directs Aug.t 1823 by J. Murray.

COD'S HEAD

TURBOT

MIDDLE OF SALMON

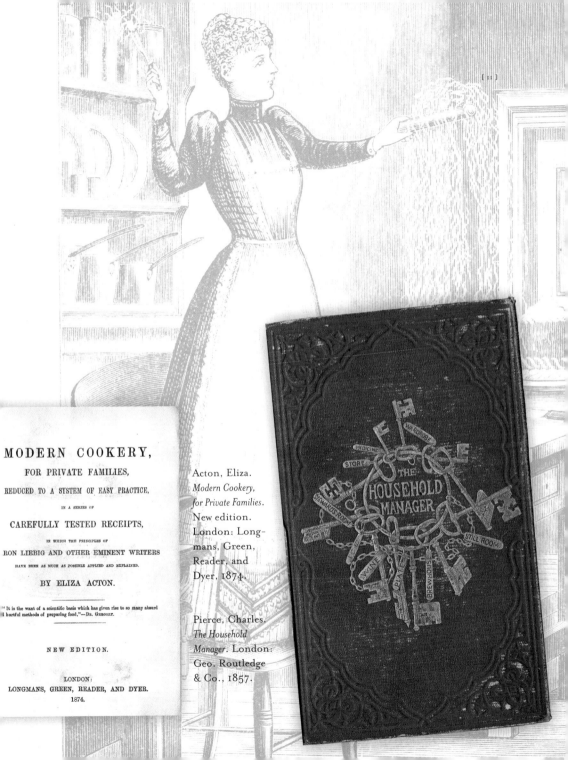

MODERN COOKERY,

FOR PRIVATE FAMILIES,

REDUCED TO A SYSTEM OF EASY PRACTICE,

IN A SERIES OF

CAREFULLY TESTED RECEIPTS,

IN WHICH THE PRINCIPLES OF

RON LIEBIG AND OTHER EMINENT WRITERS

HAVE BEEN AS MUCH AS POSSIBLE APPLIED AND EXPLAINED.

BY ELIZA ACTON.

"It is the want of a scientific basis which has given rise to so many absurd
d hurtful methods of preparing food."—DR. GREGORY.

NEW EDITION.

LONDON:
LONGMANS, GREEN, READER, AND DYER.
1874.

Acton, Eliza. *Modern Cookery, for Private Families*. New edition. London: Longmans, Green, Reader, and Dyer, 1874.

Pierce, Charles. *The Household Manager*. London: Geo. Routledge & Co., 1857.

ice ('Book of Ices,' page 22), and red Cream Ice ('Book of Ices,' page 12); the frozen, so as to prevent the different to each other; close up the shapes and charged ice-cave to freeze for about two then, when ready to serve, turn out the dry cloth. Arrange on a tall dessert

paper on it, a conical-shaped pyramid cipe), and then stick the little ices all ngraving, placing between each some of chervil. Serve at once for dessert

arranged in a nougat or sugar basket, r baskets.

pple Cream in Basket
mes en Corbeille à l'Italienne

of good cooking apples and cut put them into a stewpan with six ounces of castor sugar, one and a half pints of boiling

Marshall, Mrs A. [Agnes] B. *Fancy Ices*. London: Marshall's School of Cookery, [1894].

Jewry, Mary. *Warne's Model Cookery, with Complete Instructions in Household Management*. New edition. London: Frederick Warne and Co., [c. 1870s?].

stains, annotations, tipped-in clippings, and even a rubber-band bookmark. Priced at only a dollar, *The Home Cook Book* was assembled from women's contributions (some pirated from a similar Chicago publication) as a fund-raising project. More than twenty-five thousand copies were sold by 1881, and the book was reprinted dozens of times.[5] Such texts are evidence of the cookbook's true place: a centre of exchange, collaboration, and negotiation, from conception to kitchen.

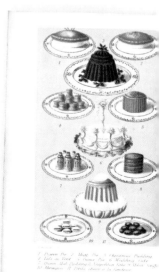

Puddings.

Bread Puddings. No. 1.

[T]ake crumbs of some stale bread, pour on them some
[boi]ling milk, cover it up, and let it remain so for 10
[mi]nutes, to allow the Bread to swell; then beat it up
[we]ll with a bit of butter; beat up with 3 or 4 eggs
[a] little sugar, stir all together; a little orange juice
[ma]y be added, also some currants: this pudding can either be
[bak]ed or boiled.

Bread Pudding No. 2.

[T]ake ½ pint milk, which let nearly boil; then pour off some
[over] a teacupful of very fine bread crumbs; allow them to
[soa]k for some time, then pour in the remainder
[of] the milk, & beat [it] up well with a fork; add 2
[egg]s beat well, and a little sugar; butter & flour a
[bas]in and put in the pudding, tie it up tight with a cloth

[...obscured by book cover...]

... pint of milk, by
... and beating up
... thicken; then butter
... little while in this m...
... [sprink]ling currants between
... ; on the top may be
... [an]other pint of milk
... [10] minutes, it is very goo[d]
[with]out preserves.

Davenport,
Laura.
*The Bride's
Cook Book*.
Toronto:
The Copp,
Clark Co.,
Limited,
1908.

MEATS

This dish of meat
is too good for
any but anglers,
or very honest
men.

Isaac Walton

SALADS

Oh, herbaceous
treat! 'Twould
tempt the dying
anchorite to eat.

Sydney Smith

DESSERTS

A good pastry-
maker is as rare
as a great orator.

L'Almanach des Gourmands

ENTRÉES

FISH

SOUPS

Muse, sing the man
who did to Paris go,
That he might taste
their soups, and
mushrooms know.

W. King

THE
BRIDE'S COOK BOOK

A SUPERIOR COLLECTION OF THOROUGHLY TESTED

PRACTICAL RECIPES

SPECIALLY ADAPTED TO THE NEEDS OF THE YOUNG HOUSEKEEPER

———

SELECTED AND ARRANGED
BY
LAURA DAVENPORT

Toronto
The Copp, Clark Co., Limited
Publishers

20th century

The twentieth century produced a wave of cooking and household science titles, many of which were inspired by the rise of home economics as a discipline. Though a small number of specialized courses in cookery had been available to women outside the home since perhaps the eighteenth century, the last decades of the nineteenth century saw the advent

Hallam,
Barbara
Halton. *Food-
Buying and Meal-
Planning*. New
York: The
Homemaker's
Encyclopedia,
Inc., 1952.

of formal cookery and household management education, and home economics classes became common fare in the twentieth century for girls and women in elementary, secondary, and post-secondary education. Fannie Farmer's comprehensive *Boston Cooking-School Cook Book*, a pedagogic, science-based text credited with popularizing level measurement, emerged from this tradition: Farmer, who began as a student at the Boston Cooking School, first revised an earlier version of the cookbook in 1896, and the work was an instant success, selling 360,000 copies by 1915. Regularly updated to fit evolving trends and concerns, the text is now in its thirteenth edition and titled *The Fannie Farmer Cookbook*.[6] Farmer's popularity in the United States was rivalled only by that of Irma Rombauer's *The Joy of Cooking*. First published in 1931, *The Joy of Cooking* was soon revised to include more cooking basics and quick and inexpensive meals. With its chatty and familiar tone, the text would become a best-seller in 1943 and remains popular today.[7] But alongside these new canonical works were diverse other forms: some books included numerous blank

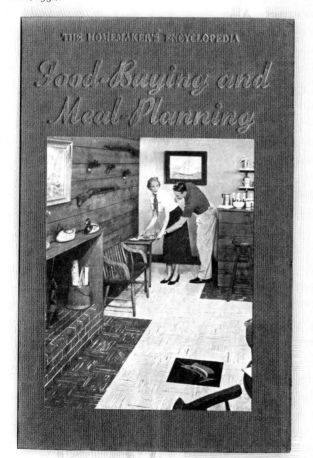

MY OWN
COOKERY BOOK

By

MRS. C. S. PEEL

Director of WOMEN'S SERVICE, MINISTRY OF FOOD, 1917-1918
Director of "DAILY MAIL" FOOD BUREAU, 1918-1920
Editor of "LE MENAGE," "THE QUEEN,"
Author of "10/- a Head for House Books," "The Single-
handed Cook," "Learning to Cook," "The Labour
Saving House," "Marriage on Small Means,"
"How to Keep House," "The 'Daily
Mail' Cookery Book," etc., etc.

" What we want is good
food at moderate cost,
and recipes which even
the inexperienced may
follow."
—*Extract from the letter of a correspondent.*

ILLUSTRATED

MRS. FRYER'S
LOOSE-LEAF
COOK BOOK

*COMPLETE COOK BOOK GIVING ECONOM-
AL RECIPES PLANNED TO MEET THE
EDS OF THE MODERN HOUSEKEEPER*

INCLUDING CHAPTERS ON
BALANCED RATIONS
ENTERTAINING SCHOOL LUNCHES
DIET FOR WEIGHT CONTROL, ETC.

ARRANGED BY
JANE EAYRE FRYER
INSTRUCTOR OF DOMESTIC SCIENCE
Author of The Mary Frances Story-Instruction Books

H BLANK PAGES FOR PRESERVING PERSONAL REC
MEMORANDA, WHICH CAN BE INSERTED IN ANY P
THE BOOK UNDER THE SUBJECTS TO WHICH THEY RE

Illustrated

THE JOHN C. WINSTON COMPAN
HICAGO PHILADELPHIA TORON

Fryer, Jane Eayre.
*Mrs. Fryer's Loose-Leaf
Cook Book.* Chicago:
The John C. Winston
Company, 1922.

"Now Good Digestion wait on Appetite and
Health on both."—*Shakespeare*

———

TRIED FAVOURITES
COOKERY BOOK

WITH

HOUSEHOLD HINTS AND OTHER
USEFUL INFORMATION

BY

MRS E. W. KIRK

REGISTERED AT STATIONERS HALL
COPYRIGHT RESERVED

Twenty-sixth and Enlarged Edition
SEVEN HUNDRED AND THIRTY-SECOND THOUSAND

EDINBURGH: A. D. JOHNSTON, 108 BUCKSTONE TERRACE
LONDON: HORACE MARSHALL & SON, TEMPLE HOUSE,
TALLIS STREET, E.C. 4

1948

D COMPANY LTD.
MBAY · SYDNEY.

923

Peel, Mrs. C.S.
My Own Cookery Book.
London: Constable
and Company, 1923.

Kirk, Mrs E.W. *Tried
Favourites Cookery Book with
Household Hints and Other
Useful Information.* 26th
and enlarged edition.
Edinburgh: A.D.
Johnston, 1948.

Thanksgiving dinner served at Good Housekeeping Institute! In testing out recipes and in planning menus to be published in Good Housekeeping or in our bulletins or our cook book, much cooking and meal making go on in our busy kitchens. Every recipe is carefully tried out, and when the result is deliciously satisfactory to our tasting staff, it is written out in a clear and concise form and added to our list of recipes Tested, Tasted, and Approved. Many of the meals we plan are prepared and served to guests and to our own staff. Only standard measuring cups and spoons tested and approved by Good Housekeeping Institute are used; all measurements are level; the cooking temperature and time are carefully recorded. You can trust every recipe.

GOOD HOUSEKEEPING
COOK BOOK

Recipes and Methods
For Every Day and Every Occasion

Tested, Tasted, and Approved By:

DOROTHY B. MARSH
KATHERINE NORRIS
ADELINE MANSFIELD

of the Institute Staff
In the Kitchens of Good Housekeeping Institute

KATHARINE FISHER, Director

Published by GOOD HOUSEKEEPING
57th Street at Eighth Avenue, New York

Marsh, Dorothy B., Katherine Norris, and Adeline Mansfield. *Good Housekeeping Cook Book*. New York: Good Housekeeping, 1933.

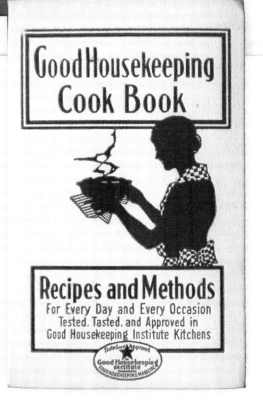

BEEF SIRLOIN

BEEF TENDERLOIN

BEEF RIBS REGULAR CUT

pages for women to add their own recipes, an acknowledgement
of the negotiability of cooking practice, while at the same time
encyclopedic manuals of household management, reminiscent
of Mrs. Beeton, remained popular. Books might reflect wartime
exigency or 1950s abundance, and many titles were little more than
quick moneymakers for enterprising publishers. Indeed, while at the
beginning of the century many households might have owned only
one or two cookbooks, families — now less likely to have servants —
were also increasingly accumulating small culinary libraries. Their
collections might even include novelty titles like Mrs. Rasmussen's
Book of One-Arm Cookery, based on a series of humorous novels by Mary
Lasswell. Twentieth-century texts, in their various forms, chart the rise to supremacy of processed foods like gelatin and canned pineapple, as well as a collective fascination with the evolving science of vitamins and nutrition, and the influence of international dishes and gourmet styles. All testify to cooking's central place in frugal household economy and extravagant entertaining alike.

HOUSEHOLD
DISCOVERIES

New Edition
Revised and Enlarged

❧ AN ❧

ENCYCLOPAEDIA
OF PRACTICAL
RECIPES AND
PROCESSES

BY SIDNEY MORSE

SUCCESS COMPANY'S
BRANCH OFFICES
PETERSBURG, N. Y. TOLEDO, OHIO
DANVILLE, ILLS.
OKLAHOMA CITY, OKLA. SAN JOSE, CAL.

Morse, Sidney. *Household Discoveries: An Encyclopaedia of Practical Recipes and Processes*. New edition. Petersburg, NY: Success Company, 1914.

Lasswell, Mary. *Mrs. Rasmussen's Book of One-Arm Cookery*. Boston: Houghton Mifflin, 1946.

Mrs. Rasmussen's Book of

ONE–ARM COOKERY

by Mary Lasswell

DECORATIONS BY GEORGE PRICE

19 46

HOUGHTON MIFFLIN COMPANY BOSTON
The Riverside Press Cambridge

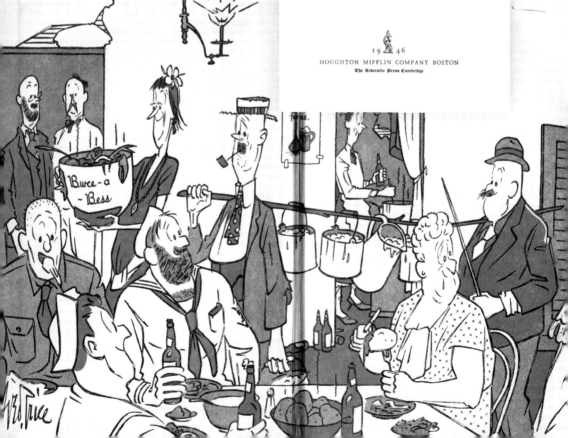

Table, Last Course

A FACSIMILE OF THE FIRST EDITION

THE JOY OF COOKING

IRMA S. ROMBAUER

WITH A FOREWORD BY EDGAR ROMBAUER

MRS RORER'S NEW COOK BOOK

A MANUAL

OF

HOUSEKEEPING

By

SARAH TYSON RORER

Author of Mrs. Rorer's Philadelphia Cook Book,
Canning and Preserving, Bread and Bread Making,
and other valuable works on cookery

PHILADELPHIA
ARNOLD AND COMPANY
420 SANSOM STREET

*Above is copy of the original title page reprinted
here for historical purposes only*

Rorer, Sarah Tyson. *Mrs Rorer's New
Cook Book: A Manual of Housekeeping*.
Philadelphia: Arnold and Company,
[1902]. Facsimile reprint. New York:
The Ladies' Home Journal Cook
Book Club, 1970.

Rombauer, Irma S. *The Joy of Cooking*.
New York: Simon & Schuster, 1931.
Reprint. New York: Scribner, 1998.

Marbled Manuscript Recipe Book. British. [Fair copy with recipes dated 1830s–1860s]. Linda Miron Distad Culinaria Collection, Bruce Peel Special Collections Library.

TO ROAST A SWAN.

Take three pounds of beef, beat fine in a mortar,
Put it into the Swan—that is, when you've caught her.
Some pepper, salt, mace, some nutmeg, an onion,
Will heighten the flavour in Gourmand's opinion.
Then tie it up tight with a small piece of tape,
That the gravy, and other things may not escape.
A meal paste (rather stiff) should be laid on the breast,
And some whited brown paper should cover the rest.
Fifteen minutes at least ere the Swan you take down,
Pull the paste off the bird, that the breast may get brown.

THE GRAVY.

To a gravy of beef (good and strong) I opine
You'll be right if you add half a pint of port wine;
Pour this through the Swan—yes, quite through the belly,
Then serve the whole up with some hot currant jelly.

N. B.—The Swan must *not* be skinned.

ANOTHER RECEIPT.

Take 2lbs. of rump steak, chop it fine, season well with spice, a piece of onion, or shalot, and butter. Rub the breast both inside and outside with beaten cloves, then stuff with the above, taking care to sew the bird up carefully, and to tie it up very tightly on the spit, so that the gravy may not escape. Enclose the breast of the swan in a meal paste, after which cover the whole bird with paper well greased with beef dripping. About a quarter of an hour before the bird is taken up, remove the paper and the paste, baste well with butter and flour till brown and frothy. A Swan of 15 lbs. weight requires about two hours roasting, with a fire not too fierce.

N. B.—The Swan must *not* be skinned.

SWAN GIBLET SOUP.

Cut 6 lbs. of the knuckle of veal, and 1 lb. of lean ham in a large dish, add three onions, two turnips, one carrot, two heads of celery, a small piece of sweet basil, marjoram, thyme, parsley, and bay leaf, and a tablespoonful of salt. Butter a stew pan lightly, put in the whole of the ingredients, add five cloves, two blades of mace and half a pint of water, stew it over a brisk fire about twenty minutes, when it becomes a nice light brown color add eight quarts of water, directly it boils place it at the corner of the stove, scald the giblets in boiling water, take them out and cut them into joints, the gizzard in four pieces, put them into the stock, and let them simmer gently until they are quite tender, take them out, strain the gravy through a cloth, skim off every particle of grease, put it into a clean stew pan with the giblets, and thicken it with arrowroot dissolved first in cold water, but do not make it too thick, finish by adding half a pint of sherry, the juice of half a lemon and two grains cayenne.

Manuscript cookbooks

Manuscript cookbooks are often a riot of scribbles and stains, flavours and fashions — multi-generational projects that echo the complexities of family and community, influence and exchange. These six examples are no exception. Women of various classes assembled manuscript recipe collections, which sometimes turned into serial

scrapbooks: a book might be passed down through generations, accumulating annotations and additions that persistently affirmed its ongoing utility. And like so many tips of icebergs, the credited recipes hint at complex communities. A New England notebook, for example, offers contributions from "Aunt Martha" and "Grandmomma," as well as brown bread from Millie Healy and a spider cornbread recipe (made in a kind of frying pan with legs) from Mrs. Stackpole, for example. Another shows pasted-in letters from the owner's acquaintances in Yorkshire, Cairo, Geneva, and Rome. Reading habits are on display, too, as many women credited their entries to local newspapers or favourite magazines.

The nature of the recipes is worth comment as well: perhaps unsurprisingly, upper-class cookbooks tend to favour instructions for fancy sauces and beverages, as well as preserves and cosmetics — which were still the domain of the mistress as manager, if not labourer. Most of these recipe books also include household tips and home remedies, suggesting women's ongoing roles as family guides and healers, even as medicine was increasingly professionalized. And despite obvious attempts to apply order through indexing, these commonplace-

style books can be delightfully chaotic, evidence of their collective authorship. Curiosities include "A Black Man's receipt for rice," a calculation of the cost of keeping a pair of carriage horses, a family tree, and a note from Eustacie E.M. Hutton, dated 12 February 1916, requesting that she be buried with a bottle of chloroform, "cork to be taken out <u>immediately</u> before my coffin is closed." With the suggestions

"Recipes." Hutton Manuscript Recipe Book. British. [1880s?]. Linda Miron Distad Culinaria Collection, Bruce Peel Special Collections Library.

"Prescriptions & Recipes." Hutton Manuscript Recipe Book. British. [1870s–1920s?]. Linda Miron Distad Culinaria Collection, Bruce Peel Special Collections Library.

Prescriptions & Recipes.

breads, sweetmeat, lamb fry, are particularly
good — a few oysters are a g⁰ improvement

Cromesques — by C Fletcher

Have some nice Croquette meat on a flat dish —
let it get quite cold, cut it in pieces about
2 inches long & ½ broad — have ready cut 12
pieces of larding bacon as thin as they can be
cut about 2 inches each way. roll the meat
in them, have a nice batter of flour &
water, a tablespoonful of salad oil &
the whites of 3 eggs beat up — mix the
batter with a fork, lift the meat, drop it
in the batter & fry in hot lard. a nice pale
brown

Take 3 carro
slices. 2 turn
a few sprig
onions, (hu
corns. 2 blea
¼ d⁰ salad
all together
with cold. — u
you like — :
or so days
will do for so
a marina
boil it. up

Take ½ ᵗᵇ of
water as list
quite tend
with a woo
stones. Pu
take the w

and corrections of friends and relatives, as well as the pasted-in contributions of strangers who published recipes in popular print, such books demonstrate how cookbooks are paradoxically prescriptive and interactive, meant to be fixed and permanent but also understood to be constantly adapted and negotiated. These assemblages, moreover, are each unique: reflecting the inner lives of their users, they might be guarded and treasured. Every manuscript cookbook, with its complexity of pedagogy and personality, is a masterpiece of obvious exchange and implied narrative, turning the ephemeral lives of women into a permanent record of individuals and communities.

"The Puritan Note Book." Manuscript Recipe Book. American. [1860s–1910?]. Linda Miron Distad Culinaria Collection, Bruce Peel Special Collections Library.

To make a cheap and agreeable beverage, superior to what the Brewers call small beer. —

Boil eight gallons of water one ounce of hops, and one ounce of ginger, cut small, all together, a short time; then put four pounds of treacle thereto, and when it is new-milk warm, put a proper quantity of barm or yeast to it, and it will ferment like common beer that is brewed from malt. The liquor will keep longer than common beer and is exceedingly pleasant in taste.

Manchester Mercury 8th May 1810

A never failing cure for the

Dissolve three drachms of prepa[red]
a quart of cold soft water, an[d]
[h]alf this quantity in the cou[rse]
[da]y. Continue this medicine
[da]ys, and that painful comp[laint]
dislodged. It may be taken
[ho]ur, but it is best after a meal
[mar]tyrs to this disorder have be[en]
[re]lieved by this simple remedy. —

Lancaster Gazette 13th Octo. 1810

A

— collection of —

miscellaneous Receipts in

— domestic oeconomy —

— the Arts &c. —

— 1807 —

"A Collection of Miscellaneous Receipts in Domestic œconomy, the Arts, &c." Manuscript Recipe Book. British. [1807–1900?]. Linda Miron Distad Culinaria Collection, Bruce Peel Special Collections Library.

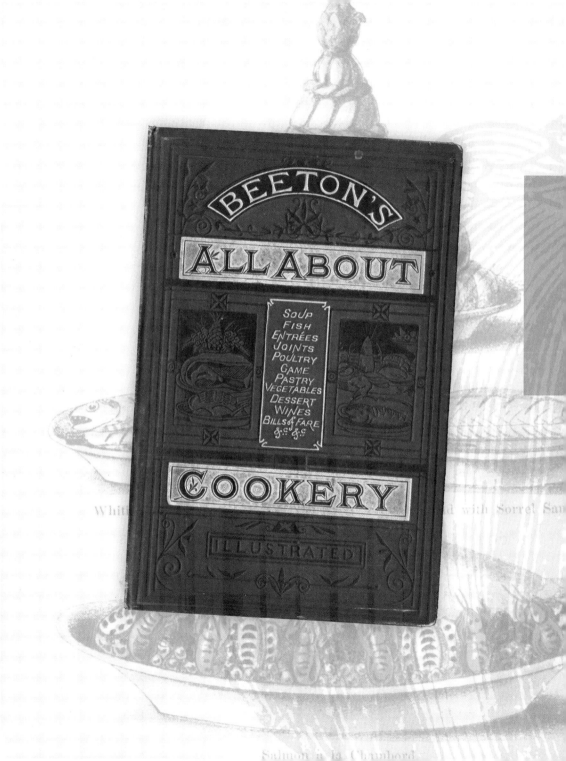

BEETON'S

ALL ABOUT

SOUP
FISH
ENTRÉES
JOINTS
POULTRY
GAME
PASTRY
VEGETABLES
DESSERT
WINES
BILLS & FARE
&c. &c.

COOKERY

ILLUSTRATED

Mrs. Beeton

Isabella Beeton was a mere twenty-one years old when she began compiling her now legendary *Beeton's Book of Household Management*. The collection was first published by her husband Samuel's company, S.O. Beeton, in installments in 1859, and then as a single volume in 1861. Priced at 7s. 6d., with 1112 pages of recipes and domestic advice,

the book became a culinary and household management touchstone, selling a reported sixty thousand copies in its first year and nearly two million by 1868.[8] Although Mrs. Beeton borrowed heavily from other texts, her work was unique for its factual, rigorously organized presentation of recipes, as well as its exposition of the historical, agricultural, and scientific elements of food. Mrs. Beeton was already producing smaller recipe collections, largely derived from the *Book of Household Management*, when she died in 1865, aged only twenty-eight. Her debt-ridden husband sold his copyrights to Ward, Lock the following year, and the company began almost immediately to publish a further range of derivations and revisions, which continue to the present day. Some of these new texts were meant

All About Cookery: A Collection of Practical Recipes, Arranged in Alphabetical Order and Fully Illustrated. Beeton's "All About It" Books. London: Ward, Lock & Co., [c. 1879?].

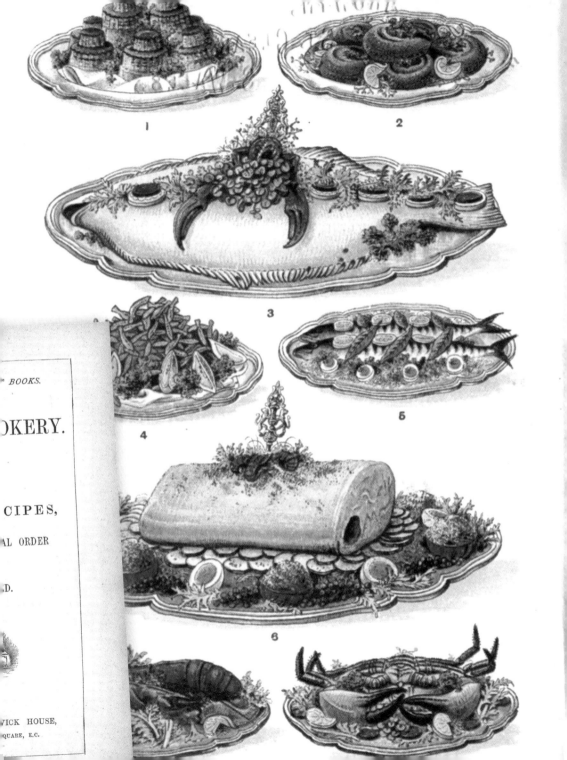

" BOOKS.

OKERY.

CIPES,

AL ORDER

D.

1
2
3
4
5
6

WICK HOUSE,
SQUARE, E.C.

FISH.

MRS. BEETON'S
BOOK OF

HOUSEHOLD
MANAGEMENT

A GUIDE TO

COOKERY IN ALL BRANCHES

DAILY DUTIES	MENU MAKING
MISTRESS & SERVANT	HOME DOCTOR
HOSTESS & GUEST	SICK NURSING
MARKETING	THE NURSERY
TRUSSING & CARVING	HOME LAWYER

NEW EDITION
REVISED, ENLARGED, BROUGHT UP TO DATE
AND FULLY ILLUSTRATED

& CO., LIMITED

1—Red Mullet. 2—Grayling. 3 John Dory.
6—Whiting 7 Salmon. 8—Herring. 9—Pla
12—Crayfish.

*Mrs. Beeton's Book of
Household Management.*
New edition. London:
Ward, Lock & Co.,
Limited, 1912.

Beeton, Mrs. Isabella.
*The Book of Household
Management.* London:
S.O. Beeton, 1861.
Facsimile reprint. New
York: Farrar, Straus
and Giroux, 1968.

E WORLD'S GREATEST COOKERY BO

as concise, working cookbooks, but the masterful, encyclopedic tome — often given as a wedding gift — was also regularly reissued. The 1869 edition of Beeton's *Book of Household Management* was the first major revision, undertaken by Samuel Beeton and Myra Browne. It included additional emphasis on innovative kitchen tools, as well as twelve new, more decorative colour plates.[9] Into the late nineteenth and early twentieth centuries, the book swelled in size and presented an increasingly stately and extravagant lifestyle, saturated with French influence. But this apogee could not long be sustained, and the Beeton books of the mid- and late twentieth century tend again toward more realistic recipes and helpful advice. Through its many iterations, the trademark "Mrs. Beeton" has assumed an almost mythological status, representing both the practicality and excess of British cookery over the last hundred and fifty years.

Mrs. Beeton's
Cookery and
Household
Management

ARD, LOCK & CO., LIMITED
NDON, MELBOURNE AND JOHANNESBURG

Mrs. Beeton's Cookery and Household Management. London: Ward, Lock & Co., Limited, 1960. Reprinted 1961.

Beeton's Every-Day Cookery and Housekeeping Book. London: Ward, Lock and Co. [1865]. Facsimile reprint. London: Bracken Books, 1984.

Farmer, Fannie Merritt.
*Food and Cookery for the Sick
and Convalescent*. Boston:
Little, Brown, and
Company, 1905.

Dietetics and *health*

Food and health have been closely connected for centuries, despite the evolution of ways of understanding the body, from the Galenic humoral system to today's scientific medicine. In the nineteenth century, food scientists broke down foods into component chemicals and minerals, diffusing their interest in substances like proteins,

carbohydrates, fats, and water to fellow experts and regular house-keepers alike, as evident in works like E. Lankester's lectures *On Food* and W. Williams's *The Chemistry of Cooking*. Justus von Liebig, a German chemist well known in nineteenth-century Britain, even founded the Liebig Extract of Meat Company, which produced a popular beef concentrate and later introduced Oxo products. Good food was also essential for health: Fannie Farmer, best known for spreading more professionalized housekeeping through the *Boston Cooking-School Cook Book*, prepared *Food and Cookery for the Sick and Convalescent* for nurses and mothers alike, envisioning that the text would be a crucial contribution to scientific, healthful cookery. Other titles endorsed more specific views: *Muscle, Brain, and Diet* encouraged the consumption of "Simpler Foods," essentially a vegetarian diet rich in milk products and pulses. The author was influenced by John Harvey Kellogg, whose Seventh Day Adventist beliefs led him to create Battle Creek Sanitarium, an elite health resort obsessed with nutrition and digestion. Of course,

Sara M. Jordan.M.D.
and Sheila Hibben
500 DELICIOUS & NUTRITIOUS RECIPES WHICH EVEN SUFFERERS FROM ULCERS AND OTHER DIGESTIVE DISTURBANCES CAN ENJOY
Introduction by HAROLD ROSS
Good Food for Bad Stomachs
14th Large Printing

Jordan, Sara M., and Sheila Hibben. *Good Food for Bad Stomachs: 500 Delicious and Nutritious Recipes for Sufferers from Ulcers and Other Digestive Disturbances*. Garden City, NY: Doubleday & Company, Inc., 1951.

CONSTITUENTS OF FOOD.

AMYLACEOUS
RICE
SAGO ARROWROOT & TAPIOCA
POTATOES

SACCHARINE
SUGAR
BEER
CARROT
PARSNIPS

OLEAGINOUS
COCOA NIBS
BACON
BUTTER SUET OR FAT

COOKED MEAT
OATMEAL
BARLEY

ON FOOD.

BEING

LECTURES DELIVERED AT THE SOUTH KENSINGTON MUSEUM.

BY

E. LANKESTER, M.D., F.R.S.

SUPERINTENDENT OF THE ANIMAL PRODUCT AND FOOD COLLECTIONS.

ON WATER.

THE object I have in view in this course of Lectures is to bring under notice the principal forms of those substances of which we partake, from day to day, under the name of Food; by means of which we live, and without which we should die. The life of man is like a fire. Just as the fire must have fuel in order that it may burn, so we must have food in order that we may live; and the analogy is in many respects quite correct; for we find that man really produces in his body a certain amount of heat, just as the fire does, and the result of the combustion of the materials of his food is the same as the result of burning fuel in a fire. Man, in fact, exists in consequence of the physical and chemical changes that go on in his body as the result of taking food.

B 2

Lankester, E. *On Food. Being Lectures Delivered at the South Kensington Museum.* London: Robert Hardwicke, 1861.

ON

...TS, SPICES, & FLAVOURS.

...rs in the life of a practical philosopher ...well known to a large number of readers in England, and which so well illustrates the subject of this lecture that I may perhaps be excused for introducing it.

"Weal pie," said Mr. Weller, soliloquising, as he arranged the eatables on the grass; "Wery good thing is a weal pie, when you know the lady as made it, and is quite sure it an't kittens; and arter all though where's the odds, when they are so like weal that the wery piemen themselves don't know the difference?"

"Don't they, Sam?" said Mr. Pickwick.

the attribution of health to food could go too far: as early as 1826 a reviewer of *A Treatise on Diet* declared that the book was little more than "a natural supplement to the prevalent fashion of referring all complaints to the effect of indigestion and bilious diseases," and would find especial popularity among "the old women and hypochondriacs in the kingdom."[10] Food safety was also a legitimate concern: fear of bread adulterated with alum rocked Britain in the 1750s, while London physician Arthur Hassall's examinations of various foodstuffs a hundred years later led to a series of reports in the *Lancet*. The popular outcry over revelations of impurities in foods as diverse as mustard, pickles, and beer, among many others, helped bring about Britain's 1860 Food Adulteration Act. Even into the 1930s, *The Eaton Pure Food Cookbook*,

Shenstone, W.A. *Justus von Liebig: His Life and Work.* Century Science Series. London: Cassell, 1895.

THE CENTURY SCIENCE SERIES.

JUSTUS VON LIEBIG

HIS LIFE AND WORK

(1803—1873)

BY

W. A. SHENSTONE, F.I.

Lecturer on Chemistry in Clifton College

CASSELL AND COMPANY, L

LONDON, PARIS & MELBOURN

1895

ALL RIGHTS RESERVED

JUSTUS VON LIEBIG

Maddocks, Mildred, ed. *The Eaton Pure Food Cook Book: Just How to Buy — Just How to Cook.* With an introduction by Harvey W. Wylie [sic]. [Toronto]: The T. Eaton Co., Canada, 1931.

THE EATON
Pure Food Cook Book

Just how to buy — Just how to cook

Edited by MILDRED MADDOCKS
Editor of the "Family Cook Book"; "Every Day Dishes"; "Brosia Meal Cook Book".

With an introduction and notes on food values by
HARVEY W. WYLIE, M.D.

Illustrated

✦T. EATON C⁰
CANADA

a Canadian publication of a *Good Housekeeping* text, included a preface from Harvey Wiley. Known as the "Father of the Pure Food and Drugs Act," which was passed in the United States in 1906 in an effort to remedy egregious offenses of food health and safety, Wiley headed the United States Food and Drug Administration until 1912, then became director of the Bureau of Foods, Sanitation, and Health for *Good Housekeeping* magazine, a post he held for nineteen years.[11] Trained in medicine and chemistry, Wiley embodies the crucial intersection between food and science; indeed, major discoveries such as the importance of vitamins or the arterial consequences of trans fats, made in the context of formal scientific research, continue to clarify and complicate our understanding of the relationship between nutrition and health.

Miles, Eustace H. *Muscle, Brain, and Diet: A Plea for Simpler Foods.* London: Swan Sonnenschein & Co., Lim., 1905.

Paris, J.A. *A Treatise on Diet.* 5th edition. London: Sherwood, Gilbert, & Piper, 1837.

A

TREATISE

ON

DIET:

WITH A VIEW TO ESTABLISH, ON PRACTICAL GROUN

A SYSTEM OF RULES

FOR THE

PREVENTION AND CURE OF THE DISEA

INCIDENT TO A DISORDERED STATE OF THE

DIGESTIVE FUNCTIONS.

Muscle, Brain, and Diet

A

PLEA FOR SIMPLER FOODS

BY

EUSTACE H. MILES, M.A. (Camb.),

Formerly Scholar of King's College, Cambridge, Assistant-Master at Rugby School, and Honours Coach and Lecturer at Cambridge University ; Amateur Champion of the World and Holder of the Gold Prize at Tennis, Amateur Champion of the World at Racquets, and of America at Squash-Tennis (1900); Member of the National Commission of Physical Education (Paris Exhibition, 1900); Author of 'The Training of the Body,' 'Lessons in Lawn Tennis,' 'How to Prepare Essays, etc.,' 'How to Remember,' etc., etc. ; Co-Editor (with Mr. E. F. Benson) of the Imperial Athletic Library

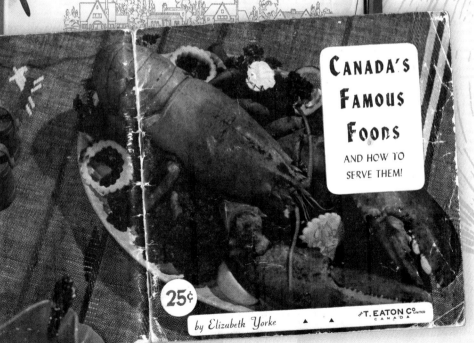

CRESCENT CREAMERY HOME SERVICE BUREAU

Directed by Graduate Dietitian

Recipe Sheet No 41

SOUR CREAM WAFFLES

1¼ cups flour
¼ teaspoon salt
½ teaspoon soda
1 cup sour cream
2 eggs

Sift together flour, salt and soda. To this add the yolks of eggs well beaten and mixed with sour cream. Mix and fold in stiffly beaten egg whites. Cook immediately. Serve with butter and maple syrup. Makes 6 waffles.

BUTTERMILK WAFFLES

2 cups flour
1 tablespoon sugar
1 teaspoon soda
3 eggs
1½ cups buttermilk
4 tablespoons melted shortening

Sift flour, soda and sugar together. Beat eggs until light and add buttermilk. Add to first mixture. Beat. Add melted butter. Cook in waffle iron.

NOTE: *See Sheet No. 17 for Recipe of Buttermilk Griddle Cakes.*

Serve Griddle Cakes or Waffles on Shrove Tuesday, February 25th

QUALITY GUARDED

TELEPHONE
37 101

CANADA'S FAMOUS FOODS AND HOW TO SERVE THEM!

25¢

by Elizabeth Yorke

T. EATON C? LIMITED
CANADA

Crescent Creamery Home Service Bureau. *Recipes.* [Winnipeg]: Crescent Creamery Company Limited, [1941].

Yorke, Elizabeth. *Canada's Famous Foods and How to Serve Them!* [Toronto]: The T. Eaton Co., Limited, Canada, 1946.

Corporate cookbooks

As mass consumer culture flourished at the end of the nineteenth and into the twentieth centuries, a new genre of recipe collections emerged: advertising cookbooks, which generally promoted a particular product or company. These came in forms as different as their products, including slim brochures, loose recipe sheets meant

to be collected, or more elaborate lithographed cookbooks, which could be acquired at low prices or sometimes for free. While many advertising cookbooks promoted new name-brand versions of familiar items (like honey or sauces) or encouraged greater and more versatile use of manufactured foods like Crisco (which Proctor and Gamble's *The Art of Cooking and Serving* used in almost every recipe), others advertised new technologies, including refrigerators and natural gas. Utility companies in particular were quick to oblige consumers who might need assistance in learning to use their unfamiliar

Splint, Sarah Field. *The Art of Cooking and Serving.* Cincinnati, OH: Proctor & Gamble, 1929.

Plum Pudding (Page 194) *Pumpkin Pie* (Page 184)
Mince Pie (Page 181)

Thanksgiving Desserts

THE ART OF

Cooking and Serving

by SARAH FIELD SPLINT

Editor Food Department, McCall's Magazine

Formerly;
Chief of Division of Food Conservation, U. S. Food Administration
Associate Editor, The Delineator; Editor, The Woman's Magazine

Procter & Gamble
CINCINNATI, OHIO

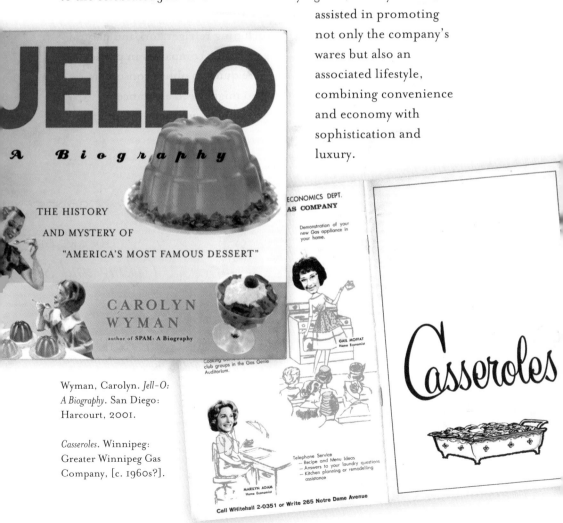

services. The Greater Winnipeg Gas Company's *Casseroles* cookbook, for example, featured professional home economists, available for home demonstrations, large group instruction, or menu suggestions. Indeed, many corporate cookbooks drew attention to their noted home economists, who apparently laboured busily in scientific test kitchens, while others introduced fictional advertising characters, from Miss Genie at the Greater Winnipeg Gas Company to the celebrated Jell-O Girl. These many figures, usually female, assisted in promoting not only the company's wares but also an associated lifestyle, combining convenience and economy with sophistication and luxury.

Wyman, Carolyn. *Jell-O: A Biography*. San Diego: Harcourt, 2001.

Casseroles. Winnipeg: Greater Winnipeg Gas Company, [c. 1960s?].

Other corporate cookbooks had little to do with a particular product, but instead served simply as an advertising vehicle. *Canada's Famous Foods* promoted the Timothy Eaton Company's Canadian heritage with recipes that included diverse fish, wild game, and maple syrup, for example. *The Metropolitan Life Cook Book*, for its part, was printed for its industrial policyholders during the

The Metropolitan Life Cook Book. [Toronto?]: Metropolitan Life Insurance Company, 1918.

Rothfeder, Jeffrey. *McIlhenny's Gold: How a Louisiana Family Built the Tabasco Empire*. New York: HarperCollins, 2007.

First World War, "[w]ith our desire to conform to suggestions of food administrators and in the hope that we can reduce the cost of living" ([2]). The book offered advice on how to reduce waste and make use of leftovers, for example, and supplied recipes requiring no fat or eggs. Advertising and company cookbooks continue to the present day and have been joined by another kind of business publication: corporate biographies. Both commissioned and non-commissioned, these often fascinating books tell the story of iconic items, adding to their flavourful mythology.

The Heinz Book of Salads.
Pittsburg: H.J. Heinz
Co., 1925.

Wisdom, Stanley.
Rubāiyāt of Canada,
or Omar Up-to-Date.
Montreal: Consolidated
Distilleries, 1928.

Rubāiyāt of Canada

WHISKY PUNCH

Fill large mixing glass three-quarters full of shaved ice; add two heaping teaspoonfuls of powdered sugar.
Put in one-quarter lemon well bruised.
Add one-third cocktail glass of water.
Two-thirds cocktail glass Embassy Liqueur Whisky.

Shake and strain into punch glass, ornament with fruit and serve.

PALACE FIZZ

Into a cocktail shaker, half filled with ice, put a teaspoonful of powdered sugar, and over it pour the juice of one lemon and one and a half cocktail glasses of Royal Palace Liqueur Whisky. Add the white of one egg.

Shake well, strain into suitable glasses and serve with soda.

A NOTHER claimed that nowhere was allure
In vessel such as 'Royal Palace Liqueur,'
Good Duncan's Scotch, and known throughout the world
As mellow, mild, all-satisfying, mature.

Then answered one with gentle Soutnern drawl,
"My gracious friends, to you I leave them all.
Give me 'Old Crow,' good Bourbon at its best;
For better whisky can no human call."

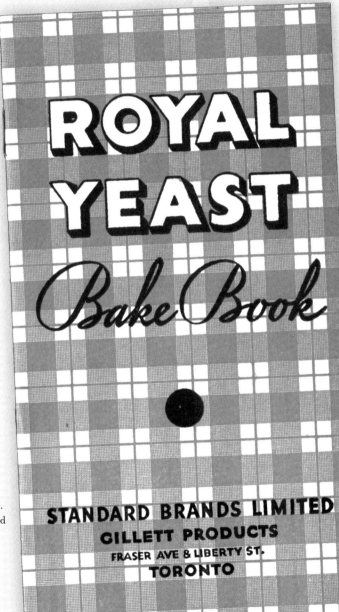

ROYAL YEAST

Bake Book

STANDARD BRANDS LIMITED
GILLETT PRODUCTS
FRASER AVE & LIBERTY ST.
TORONTO

Royal Yeast Bake Book.
Toronto: Standard
Brands Limited,
[c. 1950s?].

Flour and bread

Bread was central to the European diet, especially among the poor, and had thus long been regulated: in 1266, King Henry III's Assize of Bread and Ale, for example, controlled the weight, price, and composition of bakers' bread, and a violator in London might be dragged through the dirty streets with a bad loaf hanging around his neck.[12] As scientific models of food

came to the fore in the eighteenth and especially nineteenth centuries, both professional and home bakers were encouraged to take a more systematic approach to their work, which might include testing their supplies for purity, for example, long a concern among consumers of this staple product. Recognizing bread's centrality in the diet, *The Dietetic Value of Bread* also examined the food's nutritional characteristics, including its chemical composition and breakdown into proteins, carbohydrates, fats, minerals, fibre, and water. The author even detailed its qualities as a medicinal agent. In the Canadian context, many families baked their own bread, especially in farming areas where grain was plentiful and bakeries were scarce. These home bakers may have been heavy users of promotional cookbooks, particularly for flour (especially those brands grown and milled in Canada) and sometimes yeasts. The first Canadian recipe collection to promote Canadian flour was published by the McAllister Milling Company from Peterborough, Ontario in 1899, and publications from other companies, including Robin Hood and Five Roses flour, soon followed.[13] These often took on a collaborative character, falling someplace between a community and corporate

Five Roses Cook Book. Montreal: Lake of the Woods Milling Company Limited, 1915.

The Five Roses Food 'N Fun Book for Young Canada. Montreal: Five Roses, 1964.

The Five Roses Young Canada Bake-Off Cookbook. Montreal: Five Roses, 1965.

Insist On What You Ask For

Five Roses Flour

For Bread For Pastry

THERE IS ONLY ONE *Five Roses* FLOUR AND IT IS MILLED EXCLUSIVELY BY LAKE OF THE WOODS MILLING COMPANY, LIMITED. IT IS PACKED IN BAGS AND BARRELS AND SHOULD BEAR THE BRAND SHOWN BELOW, OTHERWISE, YOU CANNOT OBTAIN THE SAME RESULTS FROM THE ~~...OK BOOK.~~

...E LABEL SHOWN BELOW

THE FIVE ROSES
YOUNG CANADA
BAKE-OFF COOKBOOK

prize-winning bake-off recipes... year round fun party ideas... full details on the Big '65 Young Canada Bake-Offs

FIVE ROSES
FOOD'N FUN
BOOK
FOR YOUNG CANADA

1964 EDITION!
More new ideas that make your entertaining fun... and easy!
Full details on the big '64 Five Roses Young Canada Bake-Off!

HOOTEN...

COUPON

GUARANTEED
THE PURE PRODUCT OF
WESTERN
CANADIAN HARD SPRING WHEAT

LAKE OF THE WOODS
MILLING COMPANY
CANADA
TRADE MARK
REGISTERED

FIVE ROSES
FLOUR
98 Lbs.

LAKE OF THE WOODS
MILLING CO.
LIMITED
FIVE ROSES

project, as recipes might be solicited from women across the nation. Five Roses, for instance, held a national Bake-Off for young people, while Fleischmann's sponsored both local and regional baking competitions. Both companies featured the winning recipes in their publications. Such events offered women an opportunity to turn their impermanent, often overlooked daily work into minor fame and a record for posterity.

These many recipe collections range in form from cheap and ephemeral "cookbooklets" to elaborate and expensive lithographed volumes, often distributed at reduced prices or even for free. Their popularity could be immense: this version of the 1915 edition of *The Five Roses Cook Book* includes a note boasting that "over 950,000 copies are in daily use in Canadian kitchens — practically one copy for every second Canadian home." Bread continues to be a favourite among both beginner and skilled bakers, as connoisseurs try their hand at exotic varieties from around the world.

Ingram, Christine, and Jennie Shapter. *Bread: The Breads of the World and How to Bake Them at Home.* London: Hermes House, 2002.

Ogilvie's Royal Household Flour

TEN DELIGHTFUL
OGILVIE RECIPES
WHICH YOUR
FAMILY WILL LIKE

Insist on

LOOK for
the recipe coupon
inside this bag.

OGILVIE
ROYAL
HOUSEHOLD
FLOUR

BY APPOINTMENT TO
BREAD
CAKES
and
PASTRY
HIS MAJESTY

THE
WORLD'S
BEST
WHEAT

ROYAL HOUSEHOL

in all your ba

MILLED IN WINN
BY
The OGILVIE FLOUR MILL
MILLERS IN CANADA SINCE 1801

The Ogilvie Flour Mills Co., Limited

AN
INTRODUCTION
TO THE STUDY OF THE
Principles
OF
Bread-Making
— *JAGO.*

2/=

MACLAREN & SONS,
"*THE BRITISH BAKER AND CONFECTIONER*" OFFICES
24, LUDGATE HILL, LONDON, E.C.,
AND
128, RENFIELD STREET, GLASGOW.

Ten Delightful Ogilvie Recipes Which Your Family Will Like. [Montreal]: Ogilvie Flour Mills Co., Limited, [c. 1930s?].

Jago, William. *An Introduction to the Study of the Principles of Bread-Making.* London: MacLaren & Sons, 1889.

ROBERT CORNFIELD

Lundy's

REMINISCENCES *and* RECIPES FROM BROOKLYN'S LEGENDARY RESTAURANT

WITH RECIPES AND FOOD NOTES BY

KATHY GUNST

Cornfield, Robert, with Kathy Gunst. *Lundy's: Reminiscences and Recipes from Brooklyn's Legendary Restaurant*. New York: HarperCollins, 1998.

Restaurants

Satisfying the nutritional
needs of travellers was
for centuries the role
of campfires, inns, and
taverns, where culinary standards were
universally deplored. Where fuel or
kitchen facilities were scarce, local
people brought their own food to be
prepared in cookshops. By the end
of the seventeenth century Europe's
coffee houses offered light snacks,

while upper-class gentlemen sought sustenance in their private clubs. A true restaurant in the modern sense — offering diners their choice of food, timing of meals, defined portions at stated prices, served at separate tables — first appeared in Paris after 1760. M. Boulanger is said to have circumvented the restrictive rules of the several provisioners' guilds by serving *restaurants* to convalescents and others with delicate stomachs. These *restaurants* — light broths (*bouillons*) served by a *restaurateur* — were meant to restore one to health.

The French revolution swept away guild privileges, along with most of the old artistocracy, whose chefs, deprived of their employment, are said to have created the modern restaurant. Because royal chef Antoine Beauvilliers opened his restaurant in 1783, before the Revolution, this

" If all be true that I do think,
There are five reasons why men drink,
Good wine, a friend, or being dry,
Or lest we should be by-and-by,
Or any other reason why."

Henry Aldrich (1647—1710).

Boulud, Daniel, and Dorie Greenspan. *Daniel Boulud's Café Boulud Cookbook: French-American Recipes for the Home Cook*. New York: Scribner, 1999.

Savoy Cocktail Book

BEING in the main a complete compendium of the Cocktails, Rickeys, Daisies, Slings, Shrubs, Smashes, Fizzes, Juleps, Cobblers, Fixes, and other Drinks, known and vastly appreciated in this year of grace 1930, with sundry notes of amusement and interest concerning them, together with subtle Observations upon Wines and their special occasions. BEING in the particular an elucidation of the Manners and Customs of people of quality in a period of some equality.

The Cocktail Recipes in this Book have been compiled by HARRY CRADDOCK OF THE SAVOY HOTEL LONDON.

The Decorations are by Gilbert Rumbold.

NEW YORK
RICHARD R. SMITH INC.

1930

direct causality is in some dispute. Nonetheless, restaurants, patronized by both sexes, proliferated in post-revolutionary Paris, as in no other city prior to the mid-nineteenth century. Paris' close identification with restaurants, a culture increasingly reflected in both French literature and painting, prompted foreign restaurateurs to adopt French names,

London at Dinner; or, Where to Dine. London: Robert Hardwicke, 1858. Facsimile reprint. Newton Abbot, Devon: David & Charles, 1969.

Craddock, Harry. *The Savoy Cocktail Book.* New York: Richard R. Smith, 1930.

background: Ranhofer, Charles.
*The Epicurean: A Complete Treatise
of Analytical and Practical Studies
on the Culinary Art.* New York:
R. Ranhofer, 1905.

Keller, Thomas. *The French
Laundry Cookbook.* New York:
Artisan, 1999.

menus, and cuisine, as well as chefs. Paris' Maison Doré, Véry's, and Maison Prunier had their namesakes abroad: Verrey's and Prunier's in London and Maison Doree in New York City. Increased travel by ship and, later, railways ushered in the era of the *grand* hotels, which invariably included dining rooms featuring French cuisine. New York's City Hotel (est. 1794), Boston's Tremont (1829), and New York's Astor House (1836) offered à la carte dining as well as hotel accommodation, so were not free-standing restaurants.

Delmonico's, founded in 1831, set restaurant dining standards in New York for nearly a century, until prohibition of alcoholic beverages in 1920 rendered it, and its chief rival, Sherry's (est. 1881), unprofitable. The rise of the restaurant was paralleled by that of the critic. The annual *Almanach de gourmands*, edited by A.P.L. Grimode de la Reynière, was an established restaurant guidebook almost a century before the first *Michelin Guide* appeared in 1900. It spawned an endless stream of imitators, such as those featured here. Still more recently, the

Madame Prunier. *La Maison: The History of Prunier's.* London: Longmans, Green and Co., 1957.

Zagat survey (est. 1979), now owned by Google, collects, collates, and publishes — in print and on-line — restaurant ratings from more than a quarter million diners in cities around the world. And publishers continue to capitalize on the celebrity of popular chefs and restaurants by issuing cookbooks with recipes that few amateur cooks are capable of replicating.

Restaurants broke long-standing gender barriers, though the private salons (*cabinets particuliers*) offered at Maison Doré and Cadran bleu in Paris and Kettner's in London were viewed askance by the respectable. Thus, London's Simpson's-in-the-Strand featured gender-segregating dining rooms. American prohibition killed fine-dining establishments for a generation, but made liquor-free restaurants popular for family-oriented dining out. Chain restaurants appeared as early as the 1870s with Harvey Houses located along the Santa Fe railway, while others, such as Lyon's tea rooms (1894–1981) in Britain and Horn & Hardart (1888–) in America, were prototypes for today's ubiquitous, globalized, fast-food franchises.

Pawlcyn, Cindy, with Brigid Callinan. *Mustards Grill Napa Valley Cookbook*. Berkeley: Ten Speed Press, 2001.

Stewart-Gordon,
Faith. *The Russian Tea
Room: A Love Story*. New
York: A Lisa Drew
Book/Scribner, 1999.

Shelley, Henry C. *Inns
and Taverns of Old London*.
Boston: L.C. Page &
Company, 1909.

A

SHILLING COOKERY

FOR

THE PEOPLE:

EMBRACING

AN ENTIRELY NEW SYSTEM OF PLAIN COOKERY
AND DOMESTIC ECONOMY.

BY

ALEXIS SOYER,

AUTHOR OF "THE MODERN HOUSEWIFE,"
ETC. ETC.

Eightieth Thousand.

LONDON:
GEO. ROUTLEDGE & CO., FARRINGDON STREET.
NEW YORK: 18, BEEKMAN STREET.
1855.
[The Author of this work reserves the right of translating it.]

Soyer, Alexis. *A Shilling Cookery for the People*. London: Geo. Routledge & Co., 1855.

Blumenthal, Heston. *Heston's Fantastical Feasts*. London: Bloomsbury, 2010.

❖ HESTON BLUMENTHAL ❖

HESTON'S

FEASTS

PHOTOGRAPHY BY ANDY SEWELL
ILLUSTRATIONS BY TOM LANE

optomen

BLOOMSBURY

Celebrity chefs

Before the French invention of the modern restaurant, professional chefs' employment was largely restricted to royal courts and aristocratic households. François–Pierre La Verenne (1615–78), the father of modern French cuisine and author of *Le cuisinier françois* (first published in 1651 and still in print), was *chef de cuisine* to the Marquis d'Uxelles. Pioneering

restaurateur Antoine Beauvilliers (1754–1817) had served as pastry chef to the future King Louis XVIII and later wrote the classic *L'Art du cuisinier* (1814; English trans. *Art of French Cookery*, 1825). Louis-Eustache Ude (c.1769–1846), author of *The French Cook* (1813), served noble households on both sides of the Channel before becoming chef at Crockford's and later the United Service Club. Marie-Antoine Carême (1783–1833), author of *L'Art de la cuisine française* (1833–34), achieved wide fame cooking for the Emperor Napoleon, his foreign minister Tallyrand, and, briefly, the Czar of Russia and England's Prince Regent. Carême's student Charles Elmé Francatelli (1805–76) succeeded Ude as chef at Crockford's, later served as chef to Queen Victoria, and produced several best-selling cookbooks.

Noble patronage conferred prestige on these early "celebrity chefs," while their cookbooks promoted their techniques and

Soyer, Alexis.
The Modern Housewife or Ménagère.
London: Simpkin, Marshall, & Co., 1850.

THE

Modern Housewife

OR

MÉNAGÈRE.

COMPRISING

NEARLY ONE THOUSAND RECEIPTS

FOR THE ECONOMIC AND JUDICIOUS

PREPARATION OF EVERY MEAL OF THE DAY,

AND THOSE FOR

THE NURSERY AND SICK ROOM;

WITH MINUTE DIRECTIONS FOR FAMILY MANAGEMENT IN ALL ITS BRANCHES.

Illustrated with Engravings,

INCLUDING THE

MODERN HOUSEWIFE'S UNIQUE KITCHEN, AND MAGIC STOVE.

BY

ALEXIS SOYER,

AUTHOR OF "THE GASTRONOMIC REGENERATOR,"
[REFORM CLUB.]

ELEVENTH THOUSAND.

LONDON:
SIMPKIN, MARSHALL, & CO., STATIONERS' HALL COURT,
OLLIVIER, PALL MALL.
1850.

innovations and provided a measure of culinary immortality —
and perhaps even some profit. The bar of celebrity was raised to new
heights, however, by the career of Alexis Benoît Soyer (1809–58).
Following a typical round of employments in both French and English noble households, Soyer was appointed *chef de cuisine* at London's new Reform Club, which opened in 1841, for which he designed the most modern of kitchens and delighted the palates of clubmen. Much of the fame of this most celebrated of chefs owed less to his cookbooks — such

THE

COOK'S GUIDE,

AND

SEKEEPER'S & BUTLER'S ASSISTANT:

RACTICAL TREATISE ON ENGLISH AND FOREIGN
COOKERY IN ALL ITS BRANCHES;

CONTAINING

N INSTRUCTIONS FOR PICKLING AND PRESERVING VEGETABLES,
FRUITS, GAME, &c.;

The Curing of Hams and Bacon;

THE ART OF CONFECTIONERY AND ICE-MAKING, AND THE
ARRANGEMENT OF DESSERTS.

VALUABLE DIRECTIONS FOR THE PREPARATION OF PROPER DIET
FOR INVALIDS;

LSO FOR A VARIETY OF WINE-CUPS AND EPICUREAN SALADS
AMERICAN DRINKS, AND SUMMER BEVERAGES.

BY

CHARLES ELMÉ FRANCATELLI,

OF THE CELEBRATED CAREME, SEVEN YEARS CHEF DE CUISINE TO THE REFORM
CLUB, AND MAÎTRE-D'HÔTEL AND CHIEF COOK TO

HER MAJESTY THE QUEEN.

AUTHOR OF "THE MODERN COOK."

WITH UPWARDS OF FORTY ILLUSTRATIONS.

FORTY-NINTH THOUSAND.

LONDON:

ARD BENTLEY & SON, NEW BURLINGTON STREET,

Francatelli, Charles Elmé. *The Cook's Guide, and Housekeeper's and Butler's Assistant.* London: Richard Bentley & Son, 1880, and portrait frontispiece above.

as his very popular *Shilling Cookery for the People* (1854) and *The Modern Housewife* (1850) — his branded line of sauces and condiments, or his many inventions than to his charitable work in establishing soup kitchens to feed the poor and reforms to the army's commissary services during the Crimean War.

Although Soyer was not a successful restaurateur, restaurants — both free-standing and those located in grand hotels — remained essential showcases for celebrity chefs. Charles Ranhofer (1836–99), author of the monumental cookbook *The Epicurean* (1893), presided as chef at Delmonico's in New York for three decades, 1863–95. During the 1890s, Auguste Escoffier (1846–1935) and his business partner César Ritz (1850–1918) made London's Savoy Hotel world

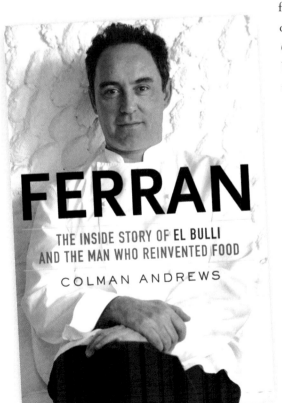

famous and later developed the Ritz chain of high-class hotels. Escoffier's *Guide to Modern Cookery* and his own brand of condiments spread his fame and influence. Although not a chef, Oscar "of the Waldorf" Tschirky (1866–1950), *maître d'hôtel* of New York's Waldorf-Astoria, was sufficiently celebrated to lend his name to a voluminous and successful cookbook. The fiercely contested awarding of the *Michelin Guide*'s coveted stars added cachet as well as book sales for celebrated French chefs Paul Bocuse (b. 1926),

Andrews, Colman. *Ferran: The Inside Story of El Bulli and the Man Who Reinvented Food.* New York: Gotham Books, 2010.

Joël Robuchon (b. 1945), and Daniel Bolud (b. 1955). Elsewhere, innovative Californian chef-restaurateurs Alice Waters (b. 1944) of Chez Panisse and Cindy Pawlcyn of the Fog City Diner and Mustards Grill, along with Ferran Adrià (b. 1962) of Catalonia's El Bulli, Heston Blumenthal (b. 1966) of England's The Fat Duck, and Toronto's Susur Lee (b. 1958), parlayed their trendy restaurants into high ratings in the Zagat survey and best-selling cookbooks.

The advent of television in the second half of the twentieth century replaced newspaper society pages as the main medium for promoting culinary celebrity. In the 1960s, it propelled an obscure American cookbook author, Julia Child (1912–2004), and Britain's Graham Kerr (b. 1934) to international fame as *The French Chef* and

A GUIDE TO
ODERN COOKERY

BY
A. ESCOFFIER
OF THE CARLTON HOTEL.

WITH POR

NEW AND REVISE

LONDON
WILLIAM HE

1909

Escoffier, A.
A Guide to Modern Cookery. New and revised edition. London: William Heinemann, 1909.

Aris, Pepita, ed.
Master Chefs of Europe. New York: Van Nostrand Reinhold, 1988.

ACADÉMIE INTERNATIONALE
DE LA GASTRONOMIE
MICHEL GENIN PRÉSIDENT

MASTER
CHEFS
OF
EUROPE

RECIPES AND MENUS FROM OVER FIFTY
OF EUROPE'S GREATEST CHEFS

INTRODUCTION BY RAYMOND BLANC
FOREWORD BY EGON RONAY PHOTOGRAPHS BY MICHAEL BOYS

FIRMIN ARRAMBIDE
GEORGES BLANC
ALAIN CHAPEL
PIERRE GAGNAIRE
MICHEL GUÉRARD
PAUL HAEBERLIN
MARC HAEBERLIN
JEAN-PIERRE HAEBERLIN
MARC MENEAU
BERNARD PACAUD
CLAUDE PEYROT
JOËL ROBUCHON
ANTOINE WESTERMANN
PIERANTONIO AMBROSI
PINA BELLINI
ANDREA DA MERANO
SERGIO LORENZI
ANGELO PARACUCCHI
PAOLO VAI
RAYMOND BLANC
JOHN BURTON-RACE
PIERRE KOFFMANN
ANTON MOSIMANN
MICHEL ROUX
ALBERT ROUX
BRIAN TURNER
DAVID WILSON

The Galloping Gourmet and turned their many cookbooks into best-sellers. Food programming grew in popularity in succeeding decades, with series such as *Iron Chef, Master Chef,* and *Top Chef.* American chefs Paul Prudhomme (b. 1940) and Emeril Lagasse (b. 1958) became public celebrities with their own cooking shows and ubiquitous cookbooks. Widespread celebrity led to chefs lending their names and brands to lines of kitchenware as well as restaurants in multiple cities around the world, where their personal supervision of the kitchens is at best nominal or merely theoretical. Scotland's Gordon Ramsay (b. 1966), international progenerative restaurateur and star of television series such as *Hell's Kitchen,* reached the height of culinary fame (as well as notoriety for his rude behaviour) and became a multi-millionaire, while American chef Anthony Bourdain (b. 1956) gained his celebrity through his exhibitionistic memoirs and has abandoned cooking for a career as author, television host, and documentary producer. With the proliferation of increasingly elaborate celebrity chef and trendy restaurant cookbooks, and entire specialty television channels now devoted to round-the-clock food programming, the public's vicarious culinary obsession appears insatiable.

THE COMPLETE
ROBUCHON

French home cooking for the way we live now

with more than 800 recipes

Robuchon, Joël.
The Complete Robuchon.
Translated by Robin
H.R. Bellinger.
New York: Alfred
A. Knopf, 2008.

Notes

1 Gilly Lehmann, *The British Housewife: Cookery Books, Cooking and Society in Eighteenth-Century Britain* (Blackawton: Prospect Books, 2003), 161.

2 See Fiona Lucraft, "The London Art of Plagiarism, Part One," *Petits Propos Culinaires* 42 (1992): 7-24; and Peter Targett, "Richard Johnson or John Farley?" *Petits Propos Culinaires* 58 (1998): 31-33.

3 Elizabeth Driver, *Culinary Landmarks: A Bibliography of Canadian Cookbooks, 1825-1949* (Toronto: University of Toronto Press, 2008), 82.

4 Nicola Humble, *Culinary Pleasures: Cook Books and the Transformation of British Food* (London: Faber and Faber, 2005), 20-21.

5 Driver, *Culinary Landmarks*, 322-23.

6 Laura Shapiro, "Farmer, Fannie," *The Oxford Companion to American Food and Drink*, ed. Andrew F. Smith (New York: Oxford University Press, 2007), 215; Laura Shapiro, *Perfection Salad: Women and Cooking at the Turn of the Century* (Berkeley: University of California Press, 2009), 106; Marion Cunningham, *The Fannie Farmer Cookbook* (New York: Knopf, 1990).

7 Anne Mendelson, "Rombauer, Irma," *The Oxford Companion to American Food and Drink*, ed. Andrew F. Smith (New York: Oxford University Press, 2007), 507.

8 Humble, *Culinary Pleasures*, 7.

9 Kathryn Hughes, *The Short Life and Long Times of Mrs. Beeton* (New York: Knopf, 2006), 361.

10 Review of *A Treatise on Diet*, by I.A. Paris, *Anderson's Quarterly Journal of the Medical Sciences* 3 (1826): 486.

11 "Harvey W. Wiley," *FDA Consumer magazine* (January-February 2006), accessed 24 July 2013, http://www.fda.gov/AboutFDA/WhatWeDo/History/CentennialofFDA/HarveyW.Wiley/default.htm

12 P. Studer, *A Fourteenth Century Version of the Mediaeval Sea-Laws Known as the Rolls of Oleron*, volume 2 of *The Oak Book of Southampton* (Southampton: Cox and Sharland, 1911), xxi-xxiv and xxvii.

13 Elizabeth Driver, "Canadian Cookbooks: In the Heart of the Home," *Petits Propos Culinaires* 72 (March 2003): 33.

THE DIETETIC VALUE
OF BREAD

BY

JOHN GOODFELLOW, F.R.M.S.

LECTURER ON PHYSIOLOGY AND HYGIENE AT THE BOW AND BROMLEY INSTITUTE,
LONDON; MEMBER OF THE SOCIÉTÉ FRANÇAISE D'HYGIÈNE; AUTHOR
OF 'IS BREAD THE STAFF OF LIFE?' 'RECENT HYGIENIC
IMPROVEMENTS IN BREAD'; 'PERSONAL AND
HOME HYGIENE,' ETC.; HON. CONSULTING
CHEMIST TO THE LONDON MASTER
BAKERS' SOCIETY

Goodfellow, John.
The Dietetic Value of Bread.
London: Macmillan
and Co., 1892.

London
MACMILLAN AND CO.
AND NEW YORK
1892

The Right of Translation is reserved

Further Reading

General

Attar, Dena. *A Bibliography of Household Books Published in Britain, 1800–1914*. London: Prospect Books, 1987.

Avakian, Arlene Voski, and Barbara Holder, eds. *From Betty Crocker to Feminist Food Studies: Critical Perspectives on Women and Food*. Amherst: University of Massachusetts Press, 2005.

Barer-Stein, Thelma. *You Eat What You Are: A Study of Canadian Ethnic Food Traditions*. Toronto: McClelland and Stewart, 1979.

Beck, Leonard. *Two "Loaf-Givers": or, A Tour Through the Gastronomic Libraries of Katherine Golden Bitting and Elizabeth Robins Pennell*. Washington D.C.: Library of Congress, 1984.

Bitting, Katherine G. *Gastronomic Bibliography*. San Francisco: A.W. Bitting, 1939.

Bower, Anne. *Recipes for Reading: Community Cookbooks, Stories, Histories*. Amherst: University of Massachusetts Press, 1997.

Brenner, Leslie. *American Appetite: The Coming of Age of a Cuisine*. New York: Bard, 1999.

Colquhoun, Kate. *Taste: The Story of Britain Through its Cooking*. London: Bloomsbury, 2007.

Davidson, Alan, ed. *The Oxford Companion to Food*. Oxford: Oxford University Press, 1999.

Davis, Jennifer J. *Defining Culinary Authority: The Transformation of Cooking in France, 1650–1830*. Baton Rouge: Louisiana State University Press, 2013.

Driver, Elizabeth. *A Bibliography of Cookery Books Published in Britain, 1875–1914*. London: Prospect Books, 1989.

Driver, Elizabeth. *Culinary Landmarks: A Bibliography of Canadian Cookbooks, 1825–1949*. Toronto: University of Toronto Press, 2008.

Duncan, Dorothy. *Canadians at Table: Food, Fellowship, and Folklore: A Culinary History of Canada*. Toronto: Dundurn Press, 2006.

Flandrin, Jean-Louis and Massimo Montanari, eds. *Food: A Culinary History from Antiquity to the Present*. New York: Columbia University Press, 1999.

Floyd, Janet and Laurel Forster, eds. *The Recipe Reader: Narratives — Contexts — Traditions*. Aldershot: Ashgate, 2003.

Freedman, Paul, ed. *Food: The History of Taste*. Berkeley: University of California Press, 2007.

Humble, Nicola. *Culinary Pleasures: Cook Books and the Transformation of British Food*. London: Faber and Faber, 2005.

Katz, Solomon, ed. *Encyclopedia of Food and Culture*. 3 vols. Scribner Library of Daily Life. New York: Scribner's, 2003.

Kiple, Kenneth, and Kriemhild Coneè Ornelas, eds. *The Cambridge World History of Food*. 2 vols. Cambridge: Cambridge University Press, 2000.

Levenstein, Harvey. *Revolution at the Table: The Transformation of the American Diet*. New York: Oxford University Press, 1988.

Lowenstein, Eleanor. *American Cookery Books, 1742 to 1860*. New York: American Antiquarian Society and Corner Book Shop, 1972.

Maclean, Virginia. *A Short-Title Catalogue of Household and Cookery Books, Published in the English Tongue, 1701–1800*. London: Prospect Books, 1981.

Mennell, Stephen. *All Manners of Food: Eating and Taste in England and France from the Middle Ages to the Present*. Oxford: Blackwell, 1985.

Oxford, Arnold Whitaker. *English Cookery Books to the Year 1850*. London: Oxford University Press, 1913.

Quayle, Eric. *Old Cookery Books: An Illustrated History*. New York: Dutton / Brandywine Press, 1978.

Robinson, Jancis. *The Oxford Companion to Wine*. Oxford: Oxford University Press, 1994.

Schenone, Laura. *A Thousand Years over a Hot Stove: A History of American Women Told Through Food, Recipes, and Remembrances*. New York: W.W. Norton, 2003.

Sherman, Sandra. *Invention of the Modern Cookbook*. Santa Barbara, CA: Greenwood, 2010.

Simon, André. *Bibliotheca Gastronomica: A Catalogue of Books and Documents on Gastronomy*. London: Wine & Food Society, 1953.

Smith, Andrew F., ed. *Oxford Encyclopedia of Food and Drink in America*. 2 vols. Oxford: Oxford University Press, 2004.

Tannahill, Reay. *Food in History*. London: Eyre Methuen, 1973.

Theophano, Janet. *Eat My Words: Reading Women's Lives Through the Cookbooks They Wrote*. New York: Palgrave Macmillan, 2002.

Toussaint-Samat, Maguelonne. *A History of Food*. Oxford: Blackwell, 1992.

Vicaire, Georges. *Bibliographie gastronomique: A Bibliography of Books Appertaining to Food and Drink and Related Subjects from the Beginning of Printing to 1890*. London: Derek Verschoyle, 1954.

Visser, Margaret. *The Rituals of Dinner: The Origins, Evolution, Eccentricities, and Meaning of Table Manners*. Toronto: Harper-Collins, 1991.

Wallach, Jennifer Jensen. *How America Eats: A Social History of U.S. Food and Culture*. Lanham: Rowman & Littlefield, 2013.

White, Eileen. *The English Cookery Book*. Blackawton, UK: Prospect, 2004.

White, Eileen. *The English Kitchen: Historical Essays*. Blackawton, UK: Prospect, 2007.

Willan, Anne with Mark Cherniavsky and Kyri Claflin. *The Cookbook Library: Four Centuries of the Cooks, Writers, and Recipes That Made the Modern Cookbook*. Berkeley: University of California Press, 2012.

Eighteenth Century

Lehmann, Gilly. *The British Housewife: Cookery Books, Cooking and Society in Eighteenth-Century Britain*. Blackawton: Prospect, 2003.

McWilliams, James E. *A Revolution in Eating: How the Quest for Food Shaped America*. New York: Columbia University Press, 2007.

Thirsk, Joan. *Food in Early Modern England: Phases, Fads, Fashions, 1500–1760*. London: Hambledon Continuum Press, 2007.

Sherman, Sandra. "'The Whole Art and Mystery of Cooking': What Cookbooks Taught Readers in the Eighteenth Century." *Eighteenth-Century Life* 28, 1 (2004): 115–135.

Nineteenth Century

Broomfield, Andrea. *Food and Cooking in Victorian England: A History*. Westport, CT: Praeger, 2007.

Freeman, Sarah. *Mutton and Oysters: The Victorians and Their Food*. London: Victor Gollancz, 1989.

Williams, Susan. *Food in the United States, 1820s–1890*. Westport, CT: Greenwood Press, 2006.

Wilson, C. Anne, ed. *Eating with the Victorians*. Stroud, Gloucestershire: Sutton Publishing, 2004.

Twentieth Century

Ferguson, Carol and Margaret Fraser. *A Century of Canadian Home Cooking, 1900 Through the '90s*. Scarborough, Ontario: Prentice-Hall Canada, 1992.

Inness, Sherrie A. *Dinner Roles: American Women and Culinary Culture*. Iowa City: University of Iowa Press, 2001.

Inness, Sherrie A. *Kitchen Culture in America: Popular Representations of Food, Gender, and Race*. Philadelphia: University of Pennsylvania Press, 2001.

Levenstein, Harvey. *Paradox of Plenty: A Social History of Eating in Modern America*. New York: Oxford University Press, 1993.

Mendelson, Anne. *Stand Facing the Stove: The Story of the Women Who Gave America* The Joy of Cooking. New York: Holt, 1996.

Neuhaus, Jessamyn. *Manly Meals and Mom's Home Cooking: Cookbooks and Gender in Modern America*. Baltimore: Johns Hopkins University Press, 2003.

Shapiro, Laura. *Perfection Salad: Women and Cooking at the Turn of the Century*. Berkeley: University of California Press, 2009.

Strauss, David. *Setting the Table for Julia Child: Gourmet Dining in America, 1934–1961*. Baltimore: Johns Hopkins University Press, 2011.

Manuscript Cookbooks

Field, Catherine. "'Many hands hands': Writing the Self in Early Modern Women's Recipe Books." *Genre and Women's Life Writing in Early Modern England*. Eds. Michelle M. Dowd and Julie A. Eckerle. Aldershot: Ashgate, 2007. 49–64.

Newlyn, Andrea K. "Challenging Contemporary Narrative Theory: The Alternative Textual Strategies of Nineteenth-Century Manuscript Cookbooks." *Journal of American Culture* 22, 3 (1999): 35–47.

Pennell, Sara. "Perfecting Practice? Women, Manuscript Recipes and
 Knowledge in Early Modern England." *Early Modern Women's Manuscript
 Writing: Selected Papers from the Trinity/Trent Colloquium.* Eds. Victoria E. Burke
 and Jonathan Gibson. Aldershot: Ashgate, 2004. 237–258.

Mrs. Beeton

Humble, Nicola, ed. *Mrs Beeton's Book of Household Management.* By Mrs Beeton.
 Oxford: Oxford University Press, 2000.
Freeman, Sarah. *Isabella and Sam: The Story of Mrs Beeton.* New York: Coward,
 McCann, & Geoghegan, 1978.
Hughes, Kathryn. *The Short Life and Long Times of Mrs. Beeton.* New York: Knopf,
 2006.
Hyde, H. Montgomery. *Mr and Mrs Beeton.* London: Harrap, 1951.
Spain, Nancy. *Mrs Beeton and her Husband.* London: Collins, 1948.

Dietetics and Health

Apple, Rima. *Vitamania: Vitamins in American Culture.* New Brunswick, NJ: Rutgers
 University Press, 1996.
Brock, William H. *Justus von Liebig: The Chemical Gatekeeper.* Cambridge: Cambridge
 University Press, 1997.
Carson, Gerald. *Cornflake Crusade.* New York: Rinehart, 1957.
Coppin, Clayton A. *The Politics of Purity: Harvey Washington Wiley and the Origins of Federal
 Food Policy.* Ann Arbor: University of Michigan Press, 1999.
Gratzer, Walter. *Terrors of the Table: The Curious History of Nutrition.* Oxford: Oxford
 University Press, 2005.
Kamminga, Harmke, and Andrew Cunningham, eds. *The Science and Culture of
 Nutrition, 1840–1940.* Amsterdam: Editions Rodopi B.V., 1995.
Mudry, Jessica J. *Measured Meals: Nutrition in America.* Albany: SUNY Press, 2009.
Ostry, Aleck. *Nutrition Policy in Canada, 1870–1939.* Vancouver: University of
 British Columbia Press, 2006.
Smith, David, ed. *Nutrition in Britain: Science, Scientists and Politics in the Twentieth Century.*
 London: Routledge, 1997.
Wilson, Bee. *Swindled: The Dark History of Food Fraud, from Poisoned Candy to Counterfeit
 Coffee.* Princeton: Princeton University Press, 2008.

Corporate Cookbooks

Allen, Bob. *A Guide to Collecting Cookbooks and Advertising Cookbooks: A History of People, Companies, and Cooking*. Paducah, KY: Collector Books, 1990.

Belasco, Warren and Philip Scranton. *Food Nations: Selling Taste in Consumer Societies*. New York: Routledge, 2002.

Marks, Susan. *Finding Betty Crocker: The Secret Life of America's First Lady of Food*. New York: Simon and Schuster, 2005.

Parkin, Katherine J. *Food Is Love: Advertising and Gender Roles in Modern America*. Philadelphia: University of Pennsylvania Press, 2006.

Shapiro, Laura. *Something from the Oven: Reinventing Dinner in 1950s America*. New York: Penguin, 2004.

Weaver, William. *Culinary Ephemera: An Illustrated History*. Berkeley: University of California Press, 2010.

Flour and Bread

Balinska, Maria. *The Bagel: The Surprising History of a Modest Bread*. New Haven: Yale University Press, 2008.

Bobrow-Strain, Aaron. *White Bread: A Social History of the Store-Bought Loaf*. Boston: Beacon Press, 2013.

Dupaigne, Bernard. *The History of Bread*. New York: Harry N. Abrams, 1999.

Jacob, H.E. *Six Thousand Years of Bread: Its Holy and Unholy History*. Garden City, NY: Doubleday, Doran, and Co., 1944.

Kaplan, Steven L. *The Bakers of Paris and the Bread Question, 1700–1775*. Durham: Duke University Press, 1996.

Kaplan, Steven L. *Good Bread Is Back: A Contemporary History of French Bread, the Way It Is Made, and the People Who Make It*. Durham: Duke University Press, 2006.

Restaurants

Adrieu, Pierre. *Fine Bouche: A History of the Restaurant in France*. London: Cassell, 1956.

Bowden, Gregory. *British Gastronomy: The Rise of Great Restaurants*. London: Chatto & Windus, 1975.

Driver, Christopher. *The British at Table, 1940–1980*. London: Chatto & Windus, 1983.

Ferguson, Priscilla. *Accounting for Taste: The Triumph of French Cuisine*. Chicago: University of Chicago Press, 2004.

Jones, Martin. *Feast: Why Humans Share Food.* Oxford: Oxford University Press, 2007.

Langdon, Philip. *Orange Roofs, Golden Arches: The Architecture of American Chain Restaurants.* New York: Knopf, 1986.

Oliver, Raymond. *The French at Table.* London: Michael Joseph, 1967.

Pinkard, Susan. *A Revolution in Taste: The Rise of French Cuisine.* Cambridge: Cambridge University Press, 2009.

Root, Waverley and Richard de Rochement. *Eating in America: A History.* New York: Morrow, 1976.

Sprang, Rebecca. *The Invention of the Restaurant: Paris and Modern Gastronomic Culture.* Cambridge: Harvard University Press, 2000.

Wheaton, Barbara. *Savouring the Past: The French Kitchen and Table from 1300 to 1779.* Philadelphia: University of Pennsylvania Press, 1983.

Celebrity Chefs

Brandon, Ruth. *The People's Chef: The Culinary Revolutions of Alexis Soyer.* New York: Walker, 2004.

Cowan, Ruth. *Relish: The Extraordinary Life of Alexis Soyer, Victorian Celebrity Chef.* London: Weidenfeld & Nicolson, 2006.

Kelly, Ian. *Cooking for Kings: The Life of Antonin Carême, the First Celebrity Chef.* London: Short Books, 2003.

Morris, Helen. *Portrait of a Chef: The Life of Alexis Soyer, Sometime Chef to the Reform Club.* Cambridge: Cambridge University Press, 1938.

Ray, Elizabeth. *Alexis Soyer: Cook Extraordinaire.* Lewes, UK: Southover Press, 1991.

Shaw, Timothy. *The World of Escoffier.* London: Vendome Press, 1994.

Soyer, Alexis. *Soyer's Cookery Book.* Facsimile reprint of an 1854 printing (the "Two Hundred and Eighty-Eighth Thousand") of the *Shilling Cookery for the People* with a differing cover title. New York: David McKay, 1959.

Tschumi, Gabriel. *Royal Chef: Recollections of Life in Royal Households from Queen Victoria to Queen Mary.* London: William Kimber, 1954.

Ude, Louis-Eustache. *The French Cook.* Facsimile reprint of the 1828 edition published by Carey, Lea, & Carey of Philadelphia. New York: Arco, 1978.

Acknowledgements

Thanks are due to Robert Desmarais, Head of the University of Alberta's Bruce Peel Library, for proposing this project; to Kevin Zak for his handsome catalogue design; to Leslie Vermeer for expertly editing the text; to Carol Irwin and Jeff Papineau for scanning images, mounting the exhibit, and displaying the books to best advantage; and to Lisa Bowker for enthusiastically promoting the exhibit.

Linda Distad "hunting and gathering" on the Internet.